D1386120

ANOUSH ABRAR
...AF
RT
SS
AU
HR
MAUREN BRODBECK
MATTHIAS BRUGGMANN
BIANCA BRUNNER
SONG CHAO
NATALIE CZECH
RAPHAËL DALLAPORTA
KATEŘINA DRŽKOVÁ
JULIE EDEL HARDENBERG
LEO FABRIZIO
MIKLOS GAÁL
GÉRALD GARBEZ
TARIK HAYWARD
RAPHAEL HEFTI
AIMÉE HOVING
PIETER HUGO
MILO KELLER
IDRIS KHAN
GÁBOR ARION KUDÁSZ
EVA LAUTERLEIN
LUCY LEVENE
RÉMY LIDEREAU
MARCELLO MARIANA
OREN NOY
RYO OHWADA
SUELLEN PARKER
TED PARTIN
CHARLOTTE PLAYER
NICHOLAS PRIOR
VALÉRIE ROUYER
MARLA RUTHERFORD
JOHANN RYNO DE WET
MARTINA SAUTER
JOSEF SCHULZ
MONA SCHWEIZER
CAROLINE SHEPARD
ANGELA STRASSHEIM
CATHRINE SUNDQVIST
SHIGERU TAKATO
PÉTUR THOMSEN
MIEKE VAN DE VOORT
RAFFAEL WALDNER
CHIH-CHIEN WANG
CARLIN WING
PABLO ZULETA ZAHR

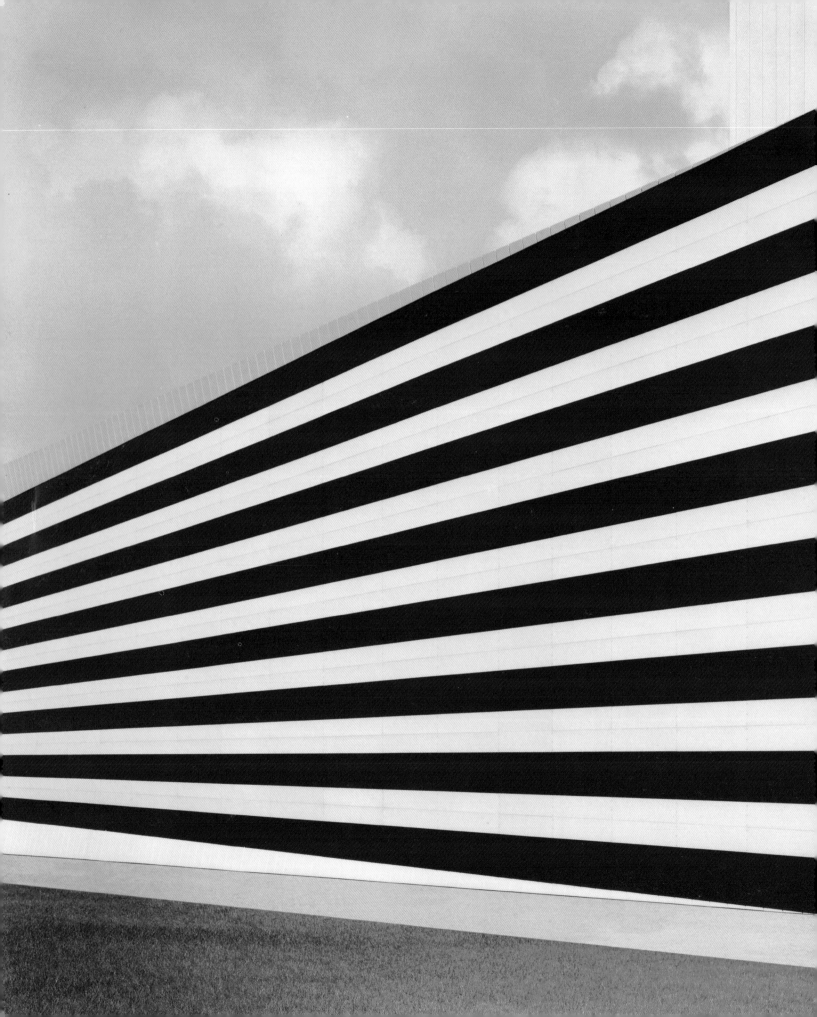

*re*Generation
50 photographers of tomorrow
2005–2025

William A. Ewing
Nathalie Herschdorfer
Jean-Christophe Blaser

with 218 illustrations, 210 in colour

Thames & Hudson

frontispiece **Josef Schulz** Red Hall #1, 2001

Published on the occasion of an exhibition of the same name:
Musée de l'Elysée, Lausanne, 23 June–23 October 2005
Aperture Foundation, New York, 6 April–22 June 2006

Texts on the photographers translated from the French by Jill Phythian

First published in the United Kingdom in 2005 by
Thames & Hudson Ltd, 181A High Holborn, London WC1V 7QX

www.thamesandhudson.com

British Library Cataloguing-in-Publication Data
A catalogue record for this book is available from the British Library

ISBN-13: 978-0-500-28582-4
ISBN-10: 0-500-28582-9

Design by Maggi Smith

Printed and bound in Germany by Steidl, Göttingen

CONTENTS

Shigeru Takato Paris V, 2004

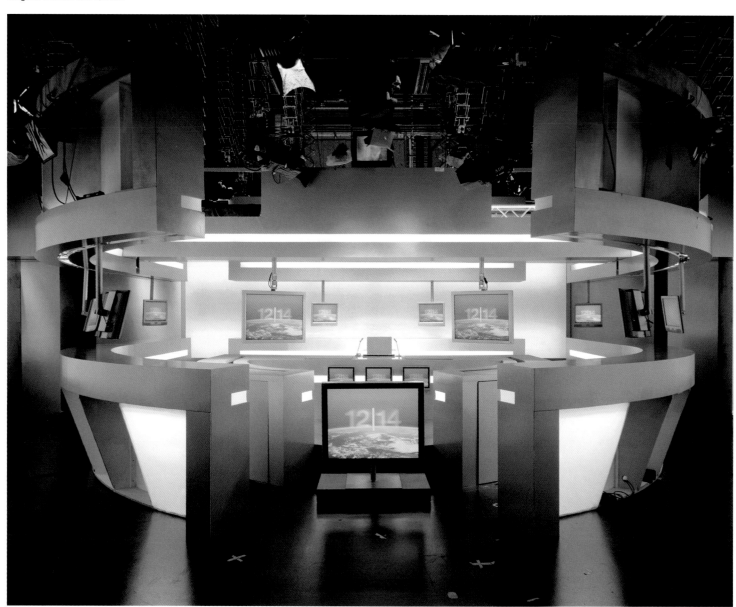

GAUGUIN'S QUESTIONS

A few short years ago, as we were all wondering what the twenty-first century would bring, I recalled the haunting title of a famous painting by Paul Gauguin, *Where do we come from? What are we? Where are we going?* The words, eternally apt, resonated strongly. In 2001 we were all keenly aware that humanity had embarked on a new century (as Gauguin was about to do), with profound hopes and fears in more or less equal measure. If anything seemed certain, it was, paradoxically, uncertainty. As the popular saying goes, questions outnumbered answers.

Gauguin's questions had an added significance for me, however, as a director of a photography museum. Gauguin was also a photographer and, when he phrased the words of his title, photography had already become indispensable to his painting. Beyond the profound philosophical sense of his questions, Gauguin must also have wondered where photography itself was going, as the issue of whether or not photography was, or could become, an art in its own right was intensely debated. A little over a hundred years later, in 2001, it seemed to me that our own 'turn-of-the-century' photographers were making very similar enquiries, questioning in fact fundamental precepts of their medium. Some were claiming that photography in its traditional guise was dead, or at least exhausted, or was perhaps metamorphosing into something too difficult at present to discern clearly. Many contemporary photographers were critiquing, even rejecting, the genres that had given order to photography since Gauguin's time – the nude, the portrait, landscape, reportage, and so on. And many were, and still are, making spirited attacks on conventional wisdom, above all the most widespread and tenacious articles of faith: that photography could capture and eternally imprison reality, and that the camera could never lie.

The photographers we know most about today – those who have established their voices over fifteen or twenty years through books and exhibitions – have articulate visions of the world, proposing their own answers to Gauguin's great questions. But what of the next generation of photographers? What will their answers be?

A century is a long time to see ahead, and in the year 2001 I had
a shorter time-frame in mind: in a few years we would mark the twentieth
anniversary of the Musée de l'Elysée, and looking back over our
accomplishments necessarily led us to ask ourselves what the next twenty
years might bring. Museums like the Elysée regularly show mature
photographers with substantial accomplishments (with twenty, thirty, forty
or even fifty years of work behind them). Which of the young photographers
emerging today, we wondered, will be fully mature in twenty years? Which
ones will be looked at, and listened to, in 2025? My fellow curators and I
decided it would be intriguing to apply more concrete versions of Gauguin's
queries to those beginners.

What *are* the young photographers up to these days? Whose influence
are they heeding, consciously or unconsciously? Are they conformist or
contentious? Idealist or realist? Escapist or engaged? Are we on the cusp
of something new (a movement, a revolt, a new dawn), or still at the tail-end
of a chapter, wallowing in the so-called decadent phase? Are emerging
photographers leaning toward classical approaches to photography or
inclined towards those of contemporary art? Are they remaining loyal to film
and chemistry or abandoning camp in droves for pixels and Photoshop?
Or are they at ease with a mix of the two technologies, according to their
needs? Where are the best young people working today? Do Europe and
North America still have the upper hand? Finally, can we speak realistically
of a new 'generation' of photographers? After all, if the term is to have any
useful sense, it must imply some common purpose or general direction,
some break with the past and some conception of the future. *reGeneration:
50 Photographers of Tomorrow 2005–2025* was conceived as a kind of time-
and-space probe: it sets out to discover answers to these intriguing questions.

reGeneration has been made possible by a generous grant from
Jaeger-LeCoultre. Located in the Vallée de Joux, famed for its tradition of
fine watchmaking, Jaeger-LeCoultre has long specialized in the manufacture
of high-quality timepieces. For well over a century the company has been

Eva Lauterlein Untitled, 2001
This double self-portrait of the artist is a hybrid product of film (analogue) and computer (digital) technologies. In its convincing yet disturbing realism, its extreme ambivalence and its desire to portray multiple truths, it embodies the spirit of the emerging generation of photographers.

considered a reference in its field. Intrigued by parallels with its own industry, Jaeger-LeCoultre shares the enthusiasm of the Musée de l'Elysée for a spirit of invention and an appreciation of mastery: where photography has the capacity to seize and record brief instants of time, condensing life, watchmakers are charged with its precise, unerring measurement. Moreover, Jaeger-LeCoultre has a proud photographic accomplishment in its past – the manufacture of a superb camera, the Compass, during the 1930s. As its English inventor, Noel Pemberton-Billing, concluded, only a Swiss watchmaker of the highest calibre could manufacture an object of such technical ingenuity. Today, the Compass remains a much sought-after collector's item, not to mention a marvellous metaphor for a photographic project that seeks to discern the direction of the future!

The Musée de l'Elysée thanks the many photographers who submitted work for consideration, and their schools, directors and professors who helped us in our quest. A full list of the candidates – who, even if not chosen for *reGeneration*, were honoured in the choosing by their schools – can be found in the endmatter of this book, along with the schools that were invited to participate. *reGeneration* is thus, by its nature, an homage paid by one generation to another.

William A. Ewing, Director, Musée de l'Elysée, Lausanne

Song Chao An Zhang, 31 years old, a miner, has been working there for 12 years with a salary of 3000 yuan a month, 2004

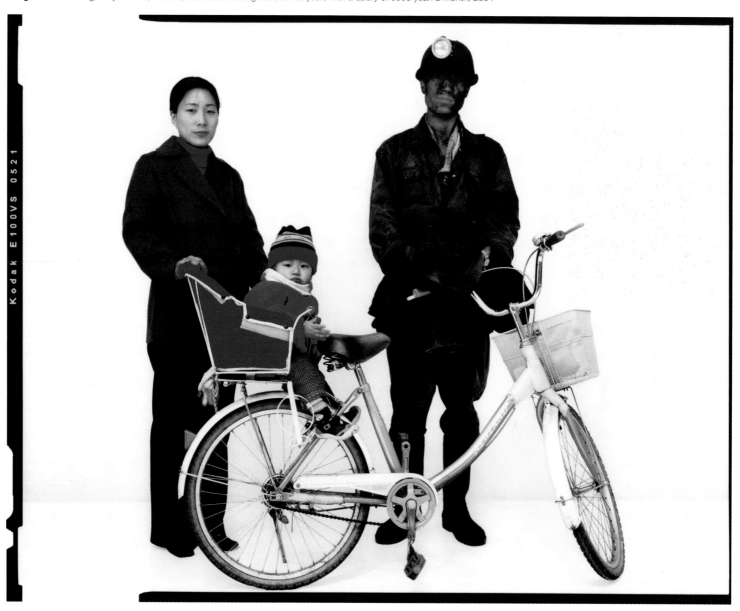

FIRST SIGHTINGS

Def. Generation: *1. The act of producing offspring; 2. The average period in which children grow up and have children of their own; 3. All of the people born and living at the same time; 4. A sense of long duration.*

Def. Regeneration: *1. Act of bringing new and vigorous life to something; 2. Re-creation; revival; re-establishment on a better basis; 3. [Theol.] The entering into a new spiritual life.*

Def. To regenerate: *1. To form again; 2. To shape, frame or fashion anew.*

Although we tend to use the term 'new generation' as a catch-all for substantive if not radical change, dictionary definitions make clear the aspect of continuity. *To regenerate* means to move forward from a measurably fixed point. But to *shape, frame or fashion something anew*, that 'something' must first exist. Photography itself pre-exists for today's younger generation, as it has for five previous generations. Since 1839 curious young people have been discovering photography for themselves, comparing its potential with what has already been done and, often dissatisfied by that gap, proposing new uses for it. The more radical of these departures have generally upset the practitioners of the previous generation, who have never liked being told that they have not fully exploited the possibilities, or, worse, that they have been following the wrong track.

Museums traditionally occupy themselves with preserving what they believe is significant from the past; they don't, as the current popular saying goes, 'do' the future – in other words, they pay little attention to the emerging generation, knowing the field will eventually be whittled down to a few. However, in the present world of image proliferation, this position is increasingly seen as anachronistic. A nineteenth- or early twentieth-century fine art museum was able to keep pace with the production of paintings and sculptures, especially as the producers were a restricted group of privileged and (for the most part) male practitioners. Photographers, however, produce individual artworks at a far faster rate (putting aside the issue of quality), outstripping the ability of museums to keep pace. If we accept 'the past' as including everything that has happened up until, literally, a moment ago, and if we consider the virtual certainty that somewhere in the world some quite extraordinary photography has been produced this very morning, then museums that follow the evolution of this medium had better rethink their criteria. The past has caught up with the present, or, as another popular saying goes, the future is now.

reGeneration set out, admittedly, with an audacious claim – to attempt to identify a good number of emerging photographers who, by 2025, could

become well-known names. Of course, one might argue that some of the photographers could very well be known *before* the quarter-century mark, so why would we want to anchor the project so specifically twenty years from now?

Photographers tend to need *at least* twenty years to solidly establish themselves. It is true that exhibitions and accolades can come thick and fast at the beginning for a chosen few, especially so in the case of sensational content, such as sexual, political or religious transgressions, or in the case of truly prodigious talent. However, the ripples of recognition still expand outwards at a certain rate. It takes time for a young photographer to find a gallery, and more time for that gallery to schedule an exhibition. Dealers then have to gauge the reaction of their clients – collectors and curators – who will also take their time making up their minds, and an initial show is often written off as an unprofitable but necessary step. When a museum curator is enthusiastic about new work, this must then be conveyed to an acquisition committee, who may well prefer to exercise a wait-and-see attitude. Even if a museum decides to offer a young photographer an exhibition, it will usually take two or three years to be realized. Public reaction also has its own time-frame for the absorption of novelty – there are limits to the attention people are willing to pay to any particular young artist. And so the years accumulate, even for prodigies.

Twenty years seems to represent the point of maturity for most photographers. Despite bursts of creativity, producing a substantial body of high-quality work inevitably takes a long period of time. To have enough first-rate imagery for an exhibition or publication – enough 'cream at the top', so to speak – a photographer has to allow for experimentation, false starts and barren periods. Even during periods of creativity, there will be days or months when the spark simply isn't there. Thus retrospectives of photographers with twenty years behind them seldom include more than 125 pictures – an average of only six or seven images a year! We cannot, therefore, expect the photographers featured in *reGeneration* to show anywhere near the level of maturity of established figures. On the other hand, they should show promise of eventually achieving it.

In setting out to discover promising photographers, the first question for the judging panel was where to look. It is very difficult to find photographers who have never had a gallery exhibition and never published an image, except perhaps in a local newspaper or obscure magazine. However, aspiring photographers often choose one proven route, that of school – of art, of photography, of communication – and this 'filter' has provided us with a workable solution to our problem. Photographers attend schools for a variety of reasons – for technical training, for intellectual stimulation, for help in launching a career – or just, perhaps, because they want to explore an interesting option before making a lifetime commitment. Most students are probably propelled into schools for a complex mix of these factors, which they themselves don't fully comprehend. For *reGeneration*'s curators, however, schools were an obvious reservoir of talent.

Admittedly, this meant acknowledging a bias: selecting future talents via schools involves excluding those photographers who have chosen to strike out on their own. Hard questions therefore must be asked of the schools themselves. Are they open to independently minded students? Are the 'stars' who teach – and competition between schools seems to be pushing them increasingly into engaging celebrated photographers – more interested in cloning themselves than in encouraging individuality? How are the schools dealing with issues of art versus commerce; fact versus fiction; classic photography versus contemporary art; what is in vogue versus what is longer lasting? Are the schools producing 'house styles'? Are they encouraging creativity or conformity?

reGeneration set out to answer some of these questions by surveying candidates from more than sixty schools worldwide. The schools were chosen by the Musée de l'Elysée's curatorial and educational staff, and the choices were based on the schools' reputations and proven results. We ensured that each of the five continents was represented, even though Europe and North America account overwhelmingly for the number of such institutions. Each school was asked to submit up to ten of their best students and/or recent graduates (from 2002 onwards), from which shortlist the curators would then select what were considered to be the fifty most accomplished practitioners.

Once gathered, the portfolios were laid out individually, studied and discussed by the panel. During the process, the names of the schools were hidden from view, so that no one would benefit unfairly from the prestige of a particular institution. There were no quotas of representation from particular countries, no political sensibilities or sensitivities taken into consideration. The curators had decided that if a particular country was not represented, so be it. We would not force the material before our eyes into a shape that distorted the geographic distribution of talent. Nor did we initially look at *curricula vitae*; whether or not an individual had already exhibited or published somewhere had absolutely no effect on our judgments.

What of criteria? On what principles were the final choices based? Our first principle was simple in theory and difficult in practice: to respect, and reflect, what we found – not to shoehorn it into a pre-existing view of where we thought photography was heading. We had, in other words, no hidden agenda. We genuinely wanted to know what young people were actually doing today, and we undertook the search in a spirit of travel to a foreign land. An unusual take on a common subject, or a conventional approach to an unusual subject, was equally interesting to us.

This openness applied as well to the genres practised. If a photographer submitted photojournalism, or edgy conceptual work, that was his or her prerogative; our task was to evaluate its quality. We were intrigued to see if new trends would emerge, although *reGeneration* did not set out to specifically reinforce them. Thus, young contenders who had chosen traditional approaches or established genres would be treated with the same respect as those who claimed to be breaking new ground. Simply put, we were looking

for photographers of all stripes who stood a good likelihood of being well established in the public eye in twenty years' time.

Another guiding principle was coherence. Each photographer had been asked to submit a brief description of his or her goals, and we wanted to judge the extent to which the work succeeded in reaching them. Moreover, there had to be a manifest intelligence behind the work. Not that theory had to dominate – this intelligence could be intuitive, quirky, anti-intellectual – but the work had to amount to more than a collection of pretty pictures. Similarly, technical proficiency was considered only in as much as technique served intent. Technical virtuosity for its own sake was dismissed as an empty vessel.

There is no way, however, of avoiding the fact that choices were based on emotional engagement with work, and on intuition, neither of which co-exist comfortably with reasoned argument. Between us, we three curators had more than fifty years' experience of looking at and working with photographs and photographers. Our choices were, at the very least, considered and informed. If we have ended up overlooking a young Cindy Sherman or an Andreas Gursky, we will humbly accept our failings – but not before 2025!

Of course, some of the *reGeneration* photographers may decide to change their careers. Some may decide to pursue other art forms, or abandon art altogether. Some may find earning a living in photography too difficult, or too compromising. The painful truth is that there is enormous competition, and, as the deadly serious childhood game of musical chairs tries to teach us all early on, there are simply not enough chairs to go around. Happily for the field of photography – and with human nature being what it is – enough fine talents grow up believing that a chair has been reserved for them.

There is an implicit understanding in this text, so far, that we are talking about emerging photographers as *artists*. Yet this oversimplifies things. Photographers also go to school to learn specialized techniques, hoping to become medical or forensic photographers, food photographers, architectural, industrial and commercial photographers, photojournalists, and documentary photographers of varying types. Most of these fields are far removed from the art world, though there is considerable osmosis when it comes to the glamorous genres of fashion and advertising and, to some extent, photojournalism. But although the photographers who submitted work for *reGeneration* occasionally included publicity, fashion or advertising imagery in their portfolios, in addition to their 'personal expression', the majority of portfolios were submitted as art, with documentary photography – for the most part photojournalism – following a close second. The absence of specialized genres is easily explained. Students at today's schools are encouraged to experiment widely and not specialize prematurely. From what the curators understand, most schools realize that a future architectural photographer, for example, is initially best served by a broad exposure to all kinds of photographic subject matter. But the question might also be legitimately asked of our project: did the young photographers put the accent on their art production because that is what

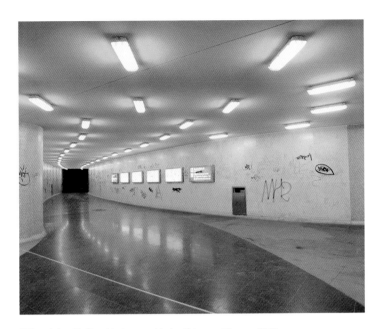

Gábor Arion Kudász Underpass, Moricz Zsigmond Square, 2004

they assumed a museum would reward? Perhaps, but we can at least report that the character of the fifty portfolios accurately reflected the character of the submissions as a whole.

What else characterized the submissions in general? One striking factor was the tendency to theorize about photography, and to situate one's own work accordingly. Roland Barthes's *Camera Lucida* dominates the charts, as it were: no photographer's name, past or present, was cited as often by the young people of *reGeneration* as this influential theorist's. Whereas preceding generations of photographers almost always cited other *photographers* as key influences (a Walker Evans, a Cartier-Bresson, a Bravo, an Arbus, etc.), the shift to a theorist suggests a sea-change in how young people are thinking about the medium. Undoubtedly, this is partly due to the increasing academization of photography, with more photographers than ever seeking university degrees, mastery of theory being a fundamental requirement. University education also exposes the students to a broad range of theorizing about media in cultural studies, the study of communications, visual anthropology and the like. Finally, today's students tend to have a better grounding in the history of photography itself, and therefore a broader view of past accomplishments. (Previous generations of photographers often had formal technical training, but followed their instincts as to subject matter, and historical knowledge was generally self-taught.) The photographers of *reGeneration* are therefore both more *self-conscious* about where they themselves fit into the historical framework (like an aspiring novelist who is enthralled by visits to a big bookstore, where he feels a sense of community), and less *self-confident* (like the now-published young writer who finds his magnum opus on the bottom shelf at the back of the store).

The *reGeneration* photographers therefore tend to inscribe their work within larger contexts: whereas a student of the 1970s or '80s might have titled her work 'Operation Room', Valérie Rouyer describes her close look at surgery on the body as an 'interrogation of the body in a transitory period of anaesthesia … [its opening leading us to] … diverse modes of representation'. The title of the work, 'Still Life', also takes a metaphysical view of her specific subject. Metaphoric or poetic titles characterize many of the portfolios submitted. This desire to inscribe work in a grander scheme may be commendable; on the other hand, is there not a danger here that the free-wheeling spirit of previous generations of photographers – for whom theory was at odds with the spontaneity and impulsiveness required of good photography – will be extinguished?

It must be acknowledged, however, that this self-consciousness can be partially explained as a defence mechanism – a realistic one, at that, given the speed at which image-making technologies are changing. Young photographers are taught that past aesthetics have always been functions of – i.e., made possible by – technical innovations (as the hand-held Leica promoted modern photojournalism), and they see with their own eyes how the axiom applies to their own age. The current speed of such change means

that the technological rug might well be pulled out from under their feet at any moment. Consequently, they feel the urge to make a mark quickly.

The *reGeneration* photographers are also aware of the equally shifting sands of theory. Fashion-conscious in every sense (this generation embraces fashion as a fundamental creative force; its very ephemerality is seen as its strength), they even view Barthes through this lens. Idris Khan's 'every …. Page of Roland Barthes' Book Camera Lucida' well illustrates this ambivalence, being both an homage and a critique: taken all together, literally, the theorist's 'lucid' ideas are rendered … opaque! Ephemeral, too, the *reGeneration* photographers know, are the fashions of photographic practice. Taking a hard look at where the great photographers of her teacher's generation have ended up, Carlin Wing's 'anthropological' documents show their iconic images have achieved the status of relatively cheap designer paraphernalia, useful to spruce up a dull office or featureless corridor – little more than upscale posters. Wing might really be asking her fellow *reGeneration* photographers: *is this where we are going to end up, too?*

One of the most striking factors in the *reGeneration* selection is the absence of traditional black-and-white imagery (confirmed again in the totality of submissions). It is ironic that Ted Partin, one of the two exceptions (Valérie Rouyer being the other), has chosen black-and-white photography for his portraits of members of 'the MTV generation' – young people whose lives are saturated with shimmering, electronic colour. It appears that, for most young photographers, *not* to use colour photography would seem as perverse as adhering to black-and-white television.

Few of the *reGeneration* photographers would today argue that photography's main task is to convey 'the truth', to provide objective witness to the world – a faith that guided generations of photographers. Fiction, or fictions, one might also conclude, are more truthful for young photographers. (Even the emerging photojournalists like Christoph Bangert, Matthias Bruggmann and Charlotte Player seem to want to show aspects overlooked by the established media.) With a well-stocked little 'photoshop' in every home, and everyone both merchant and customer, the tailoring of imagery is commonplace, the colour of sky and sea no longer a dictate of nature but a question of personal taste, or perhaps a momentary whim. The *reGeneration* photographers are, it seems, out to comment on the state of the world, not to discover it. They abstract from it, looking for underlying structures rather than dramatic moments; they tend to form their statements in series of images, rather than look for what older photographers call 'great' pictures. And if, rather than finding their subject matter, they have to *construct* it (by staging or reworking it later on the computer), they see their work as no less truthful, and arguably more so. Keren Assaf's Israeli family is real, but their behaviour is a *mise en scène* under her close direction.

Although the digital revolution has arrived, the *reGeneration* photographers have not embraced it uncritically; they pick and they choose. For some, registering images on film remains an essential ingredient, if only

a starting point: Eva Lauterlein's portraits start with such studies – up to thirty shots from different angles for a single portrait – which are then recombined seamlessly via computer. Extended to include environments, Caroline Shepard's portraits follow a similar course. We are light years away, here, from the 'decisive moment', that split-second which professes to tell all the truth that needs to be told about an event: these works are built up in the studio, slowly and painstakingly, as painters used to do. Even Pablo Zuleta Zahr's seeming snapshots are in fact complex computer reworkings – all the passers-by in a particular place over twenty-four hours are later regrouped according to clothing motifs. But Zahr still counts on our old habits of reading such photographs as records of chance encounters – of, in other words, 'decisive moments'.

As the curators expected, several shifts in contemporary photography have been confirmed in the *reGeneration* photographers. The nude as traditionally practised has practically disappeared. The studio portrait, in which the focus was traditionally placed on individuality and the revealing of character (or 'inner being'), has given way to a classification of types, as reflected in Marco Bohr's 'Uniform' series with titles like 'Hip Hop Kid', or Raphael Hefti's 'Beauticians' – the latter more like uniformed front-line soldiers ready for consumer warfare than flesh-and-blood individuals. The treatment of landscape is also light years removed from the heroic visions of, say, an Ansel Adams. For *reGeneration* photographers, landscapes anywhere in the world are mostly artificial constructs, and mostly interchangeable. Leo Fabrizio's Bangkok sites, for example, are indistinguishable from those of New Jersey. As for the long-dominant mode of street photography, it is nowhere to be seen.

But these are all tentative observations, as we have to accept that the photographers' interests and approaches will undoubtedly shift over time. Some will probably dismiss their '*reGeneration* work' as immature or inconsequential, while others may go on to extend and develop it. As for the questions we asked initially about the job the schools are doing, we can only judge by the results, and the rich diversity of work in *reGeneration* seems to suggest a general climate of openness and professionalism. For answers to Gauguin's great questions, however, it would be unfair to push the *reGeneration* photographers prematurely. They have twenty years to formulate thoughtful answers.

William A. Ewing
Nathalie Herschdorfer
Jean-Christophe Blaser

ANOUSH ABRAR

KEREN ASSAF

CHRISTOPH BANGERT

SAMANTHA BASS

JARET BELLIVEAU

MARCO BOHR

MAUREN BRODBECK

MATTHIAS BRUGGMANN

BIANCA BRUNNER

SONG CHAO

NATALIE CZECH

RAPHAËL DALLAPORTA

KATEŘINA DRŽKOVÁ

JULIE EDEL HARDENBERG

LEO FABRIZIO

MIKLOS GAÁL

GÉRALD GARBEZ

TARIK HAYWARD

RAPHAEL HEFTI

AIMÉE HOVING

PIETER HUGO

MILO KELLER

IDRIS KHAN

GÁBOR ARION KUDÁSZ

EVA LAUTERLEIN

LUCY LEVENE

RÉMY LIDEREAU

MARCELLO MARIANA

OREN NOY

RYO OHWADA

SUELLEN PARKER

TED PARTIN

CHARLOTTE PLAYER

NICHOLAS PRIOR

VALÉRIE ROUYER

MARLA RUTHERFORD

JOHANN RYNO DE WET

MARTINA SAUTER

JOSEF SCHULZ

MONA SCHWEIZER

CAROLINE SHEPARD

ANGELA STRASSHEIM

CATHRINE SUNDQVIST

SHIGERU TAKATO

PÉTUR THOMSEN

MIEKE VAN DE VOORT

RAFFAEL WALDNER

CHIH-CHIEN WANG

CARLIN WING

PABLO ZULETA ZAHR

THE PHOTOGRAPHERS

Texts by Nathalie Herschdorfer

ANOUSH ABRAR

Switzerland, b. Iran 1976
ECAL, école cantonale d'art de Lausanne,
Switzerland, 2002–2004

Anoush Abrar is interested in communities. In a series
created between 2003 and 2004, his attention was
devoted to a rather unusual kind of community:
RealDoll™ sex dolls, who bear a striking resemblance
to real women. Life-sized, they are available in a
wide variety of models, with many different faces
and just as many body types, ranging from skinny
to curvaceous, all made to satisfy their buyer's every
sexual fantasy. By focusing on the ultra-realistic
look of these dolls, Anoush Abrar subjects us to
a volley of questions about a society in which the
reification of human beings and the humanization
of objects have become common currency, making
it increasingly hard to tell the difference between
true and false, real and ideal. This observation of
society is continued in a second project devoted
to a little-known community: the Iranian Jews.
Focusing his research on Los Angeles, the city
with the highest concentration of Iranian immigrants
in the world, Abrar reminds us that a significant
number of Iranians belong to the Jewish faith, giving
the lie to clichés about the religious fundamentalism
of homogeneous communities. Through his work,
Anoush Abrar shows that even within a multicultural
society, identities are much harder to pin down than
first appearances suggest.

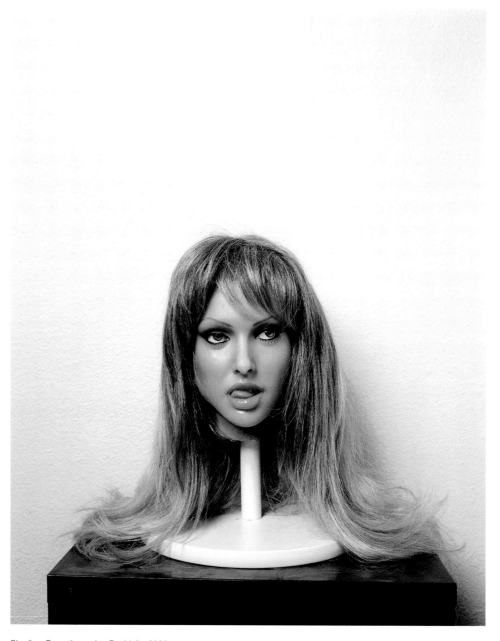

Charlize. From the series *Realdolls*, 2003

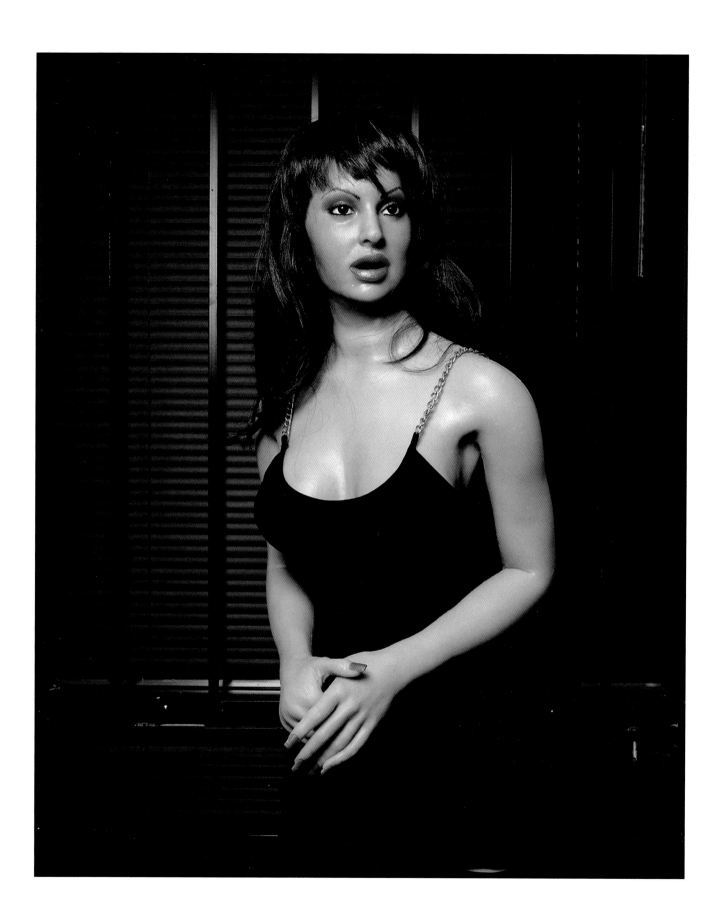

Samuel. From the series *Iranian Jewish Community in Los Angeles*, 2004

KEREN ASSAF

Israel, b. 1978
Bezalel Academy of Art and Design, Israel,
1999–2003
School of Visual Arts, United States, 2001–2002
School of Art Camera Obscura, Israel. 1998–1999

Keren Assaf tries to understand Israeli society – her own landscape and culture – by comparing the Israeli dream with the American dream. What influence does American culture have on the Middle East as a whole, and on Israel in particular? While taking part in an exchange with a New York art school, Assaf began to collect images of American families and suburbs. Inspired by advertising techniques, she composed and staged her pictures in a way designed to give the impression of 'an ideal family, pastoral surroundings, a gleaming car, a beautiful house'. It goes without saying that none of these things is 'real'. Back in Israel, she got her family to take part in staged scenes that are reminiscent of movies, in order to ask questions about Israeli reality. She shows that the differences between Israel and the US are beginning to blur, that the suburbs of both countries are becoming increasingly similar, and that this trend of conforming with the American way of life is often used as a way of escaping from life in Israel.

Untitled, Israel, 2003

Untitled, Maryland, USA, 2002

CHRISTOPH BANGERT

Germany, b. 1978
International Center of Photography, United States, 2002–2003
Fachhochschule Dortmund, Germany, 1999–2002

Christoph Bangert's work examines one of the most reported-on places in the world: Palestine. People in Europe and the US are aware that the conflict between the Israelis and the Palestinians has been going on for decades, and Bangert wondered if this situation might have created a kind of fatigue in international public opinion. The war continues to take a high toll of victims, particularly among women and children. This led Bangert to take photographs of women from all walks of life, including those from the most conservative religious backgrounds, who often bear the burden of the catastrophes caused by the conflict. Bangert's focus, however, is not exclusively on women. His inventory of the situation ranges from the welfare programmes run by Hamas in Gaza to the security barriers put in place by the Israeli army to keep the two communities apart.

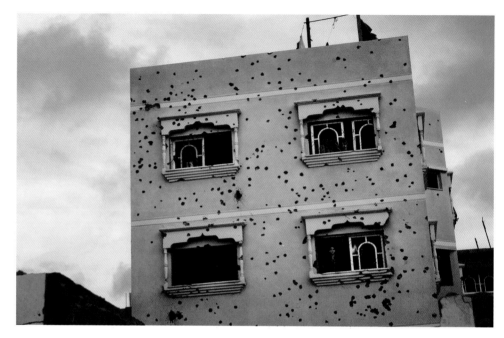

A Palestinian home damaged by Israeli fire. Khan Yunis, Gaza Strip, Palestine, 2003

Nancy is sleeping in Nura's arms. Jamil is hiding. Rafah, Gaza Strip, Palestine, 2003

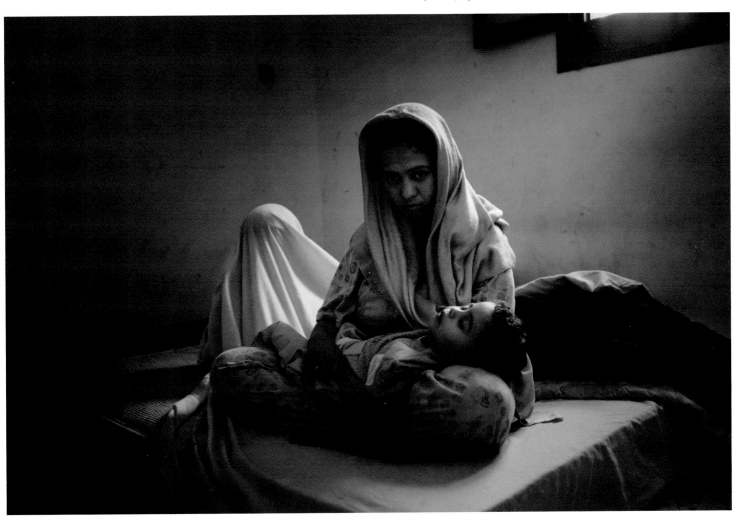

The funeral of a Hamas fighter. Rafah, Gaza Strip, Palestine, 2003

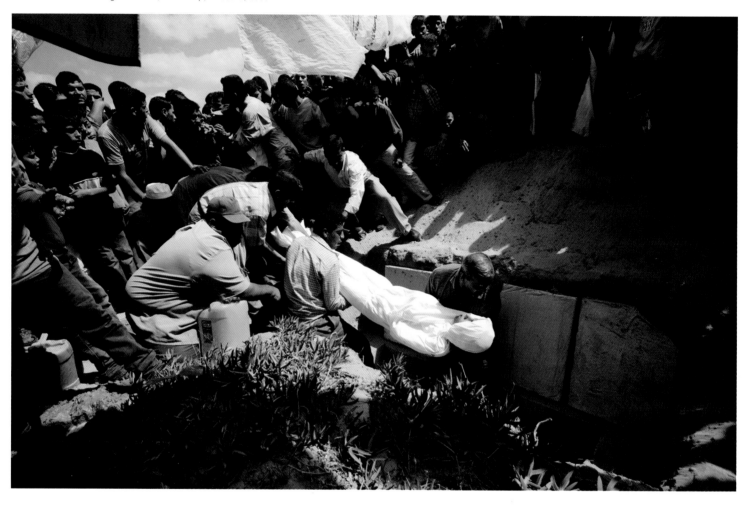

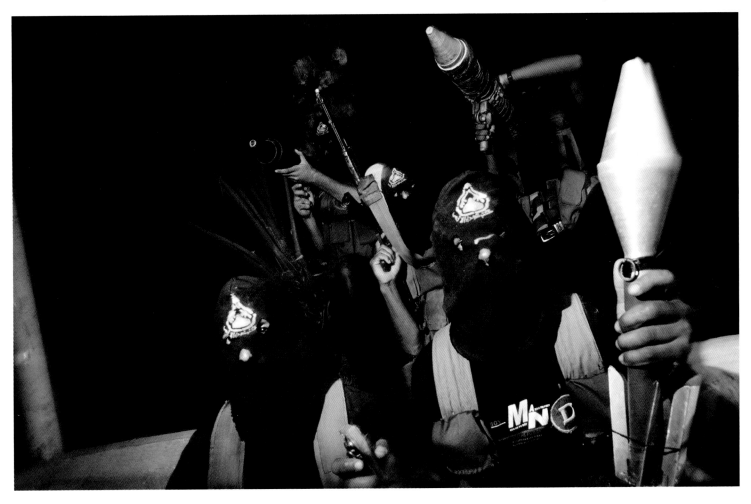

SAMANTHA BASS

United States, b. 1971
Yale University School of Art, United States,
2002–2004
Vassar College, United States, 1990–1994

The reportage work of Samantha Bass tackles an
issue that has recently been in the public eye but
is still rarely exposed to view. Since 2004, she has
taken photographs of industrial-scale livestock
farming. Shocked by the conditions in which the
animals live and die, she obtained permission to go
inside several specialized meat plants. Focusing on
rearing and abattoir conditions, the work unflinchingly
depicts an industry that treats animals destined for
slaughter in the most unceremonious fashion. Bass
shows scenes that are kept out of sight of the
general public, forcing viewers to think about
the origins of the meat they consume.

Milking Room, Connecticut, 2003

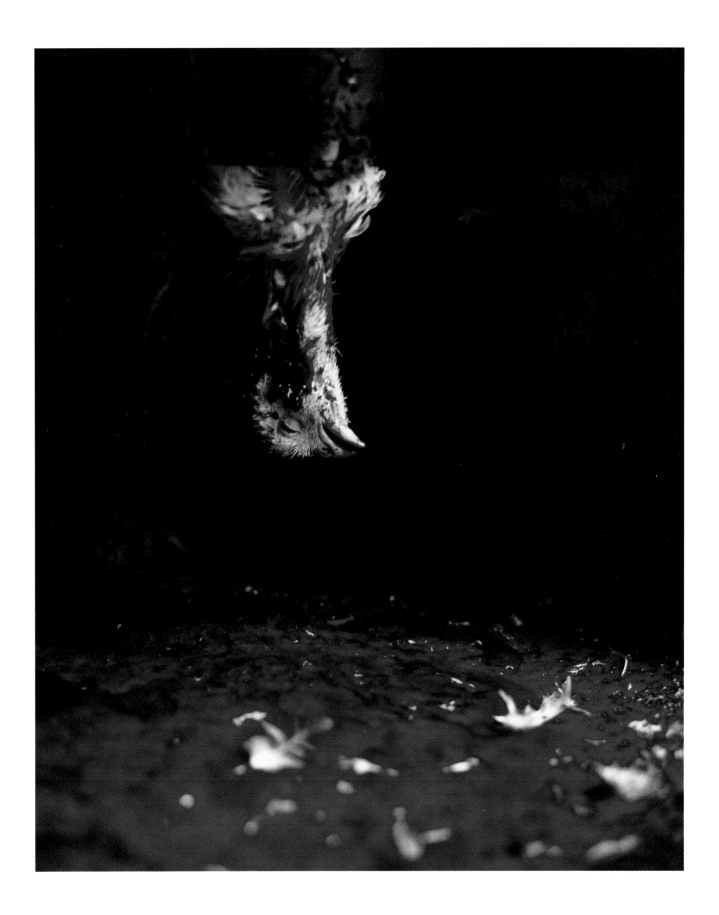

Turkey Feathers, Connecticut, 2003

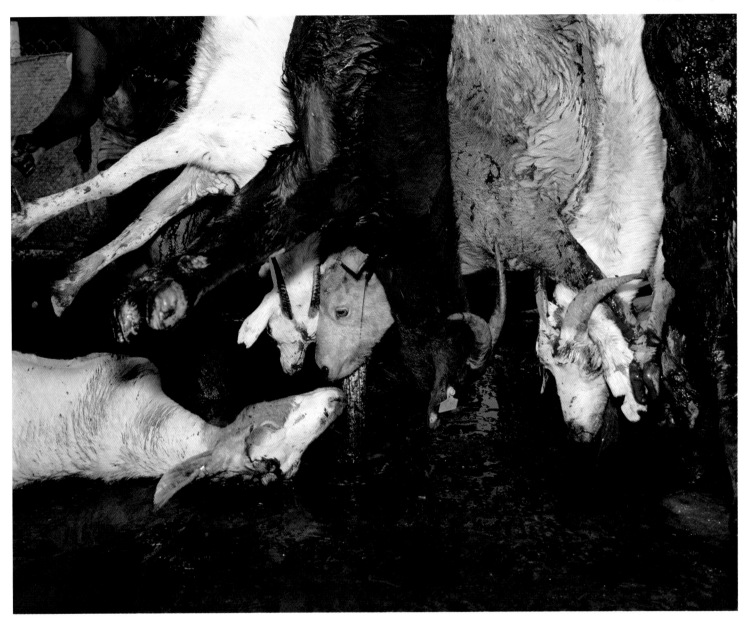

JARET BELLIVEAU

Canada, b. 1981
Nova Scotia College of Art and Design, Canada,
since 2001

Interested in the relationships that are built up within
families, Jaret Belliveau spent several years taking
reportage pictures of his own family, with each family
member being shown in his or her own environment.
While in the midst of this project, he suddenly learned
that his mother had cancer. The series *Familial
Endurance* followed the day-to-day existence of
people whose lives had been turned upside down by
the presence of serious illness. Jaret Belliveau tried
to use reportage to depict the personal challenges
that each of his relatives faced when thrown into a
situation that none of them could control.

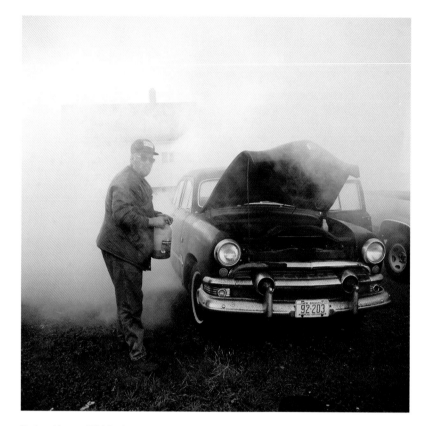

Dad working on 1951 Ford.
From the series *Familial Endurance*, 2004

Two weeks before diagnosis.
From the series *Familial Endurance*, 2004

Untitled.
From the series *Familial Endurance*, 2004

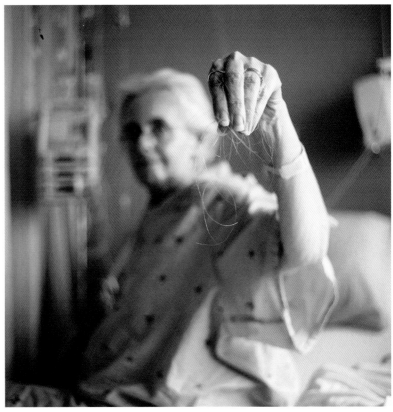

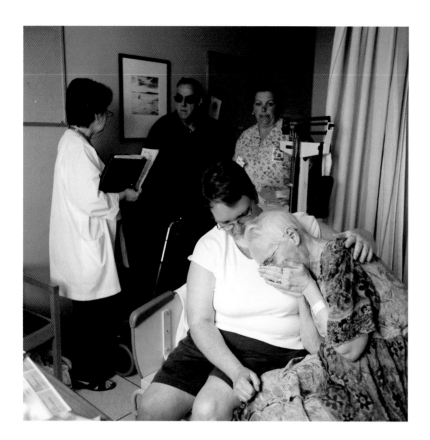

Uncertain of continuing medical insurance coverage.
From the series *Familial Endurance*, 2004

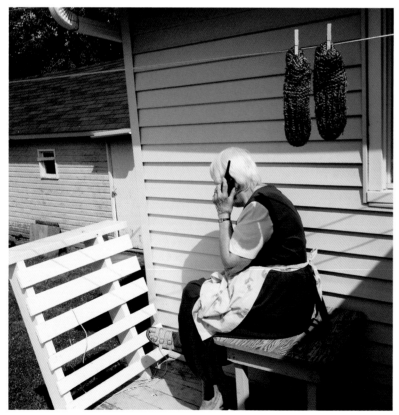

Updating relatives.
From the series *Familial Endurance*, 2004

Chicken soup and crackers.
From the series *Familial Endurance*, 2004

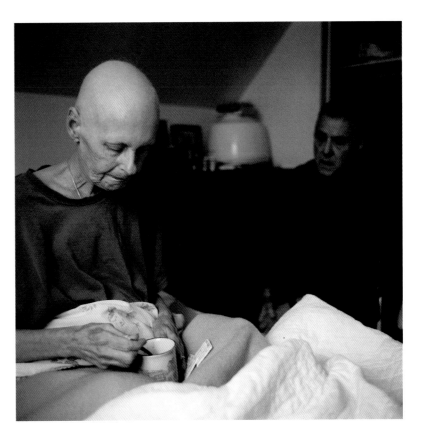

Re-admitted (attempting to increase nutrient levels).
From the series *Familial Endurance*, 2004

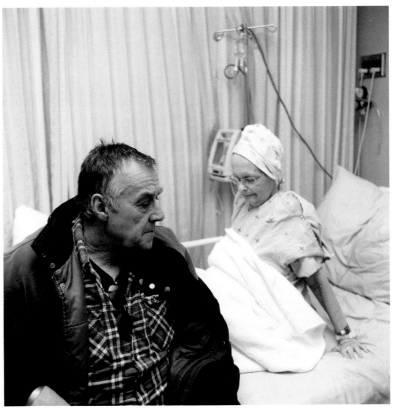

MARCO BOHR

Germany / Canada, b. 1978
Ryerson University, Canada, 1999–2003
Nihon University, Japan, 2004
Napier University, Edinburgh, Scotland, 2002

Originally from Germany but now based in Canada, Marco Bohr immersed himself in Japanese society. Confronted by a culture that can at first be puzzling to a Westerner, he began his examination of Japan by looking at people through their uniforms, finding that he could use this visual method of classification as a point of reference. In fact, representing social categories is not his real interest. He focuses his attention on the details – facial expressions and poses – that allow him to tell his subjects apart. This exploration of Japanese society was continued in his series *Observatories*. Contemplation and meditation are practices that are closely connected and well-established in everyday life in Japan. As a result of this, landscape designers, town planners and architects include spaces intended for contemplation within modern-day cities. In Marco Bohr's photographs, however, the views themselves are absent, and a hazy landscape is all that can be seen. The photographer's attention is focused on the observers themselves, rather than the thing that they are observing. This creates a subtle *mise en abîme* effect, from the observers to the photographer, and from the photographer to the viewer.

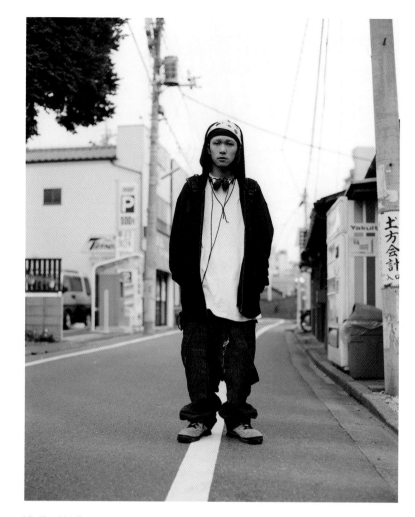

Hip Hop Kid. From the series *Uniforms*, 2003

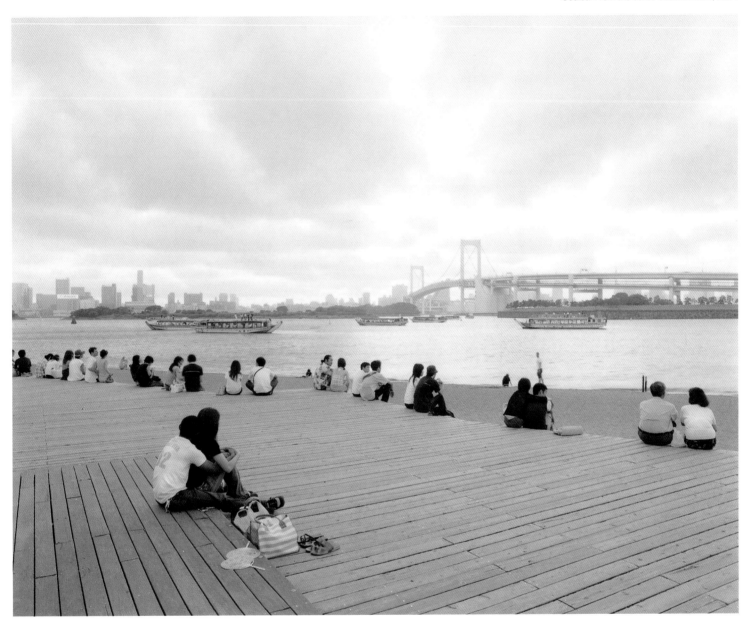

Sunshine City. From the series *Observatories*, 2004

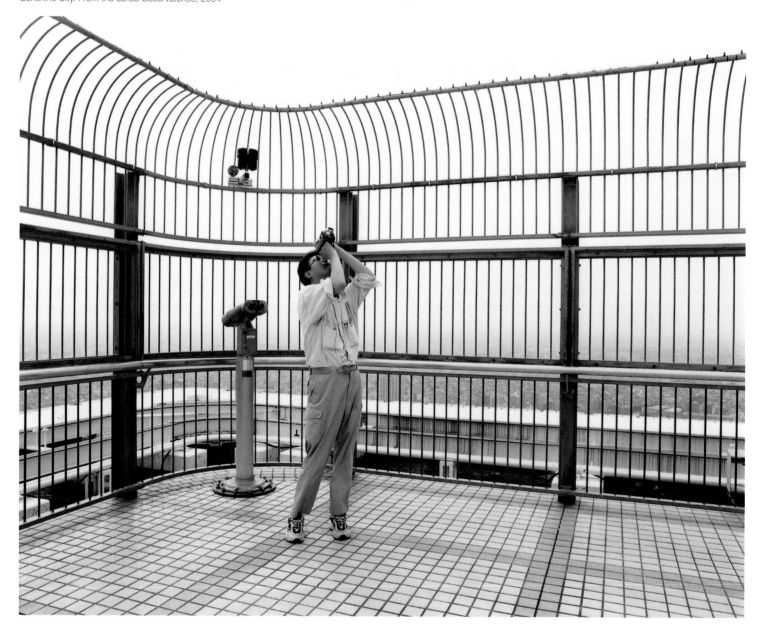

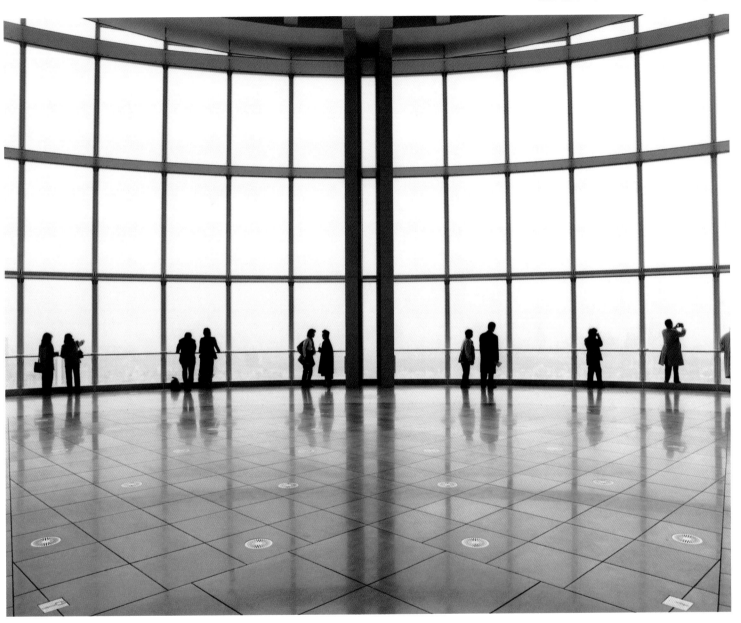

MAUREN BRODBECK

Switzerland, b. 1974

Art Center College of Design, United States,
2001–2004

Vancouver Film School, Canada, 1996

Mauren Brodbeck examines the built spaces that are created inside cities by photographing buildings that are considered ordinary parts of the urban landscape. Warehouses, car parks, buildings made around metal frameworks: these are objects that are both present and absent, neutral masses that occupy space but never attract the attention of passers-by. By pointing her camera at structures that could be called insignificant, she transforms them into sculptures with a powerful visual technique that she has developed, using blocks of monochrome colour that are sometimes present in situ and sometimes created afterwards by blocking out the buildings. Mauren Brodbeck believes that the medium of photography has a part to play in renewing the way that we look at the often banal-seeming everyday world around us.

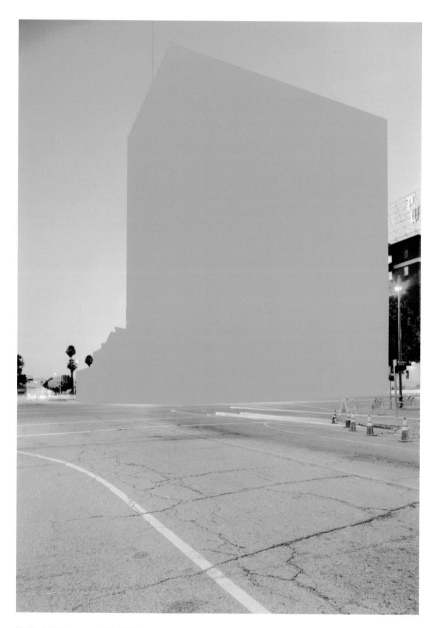

Untitled Urbanscape #17, 2004

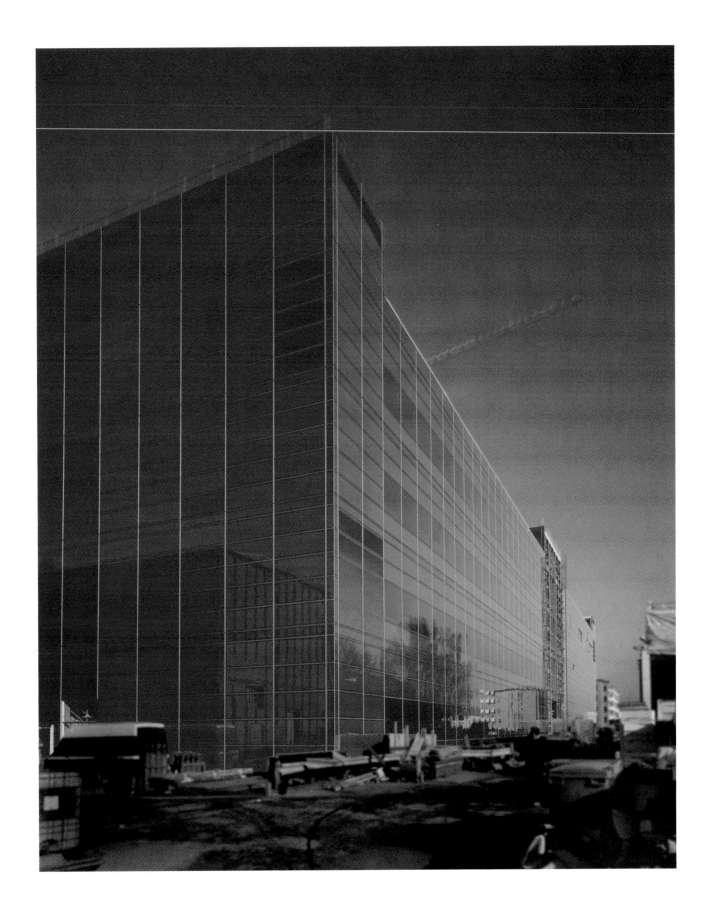

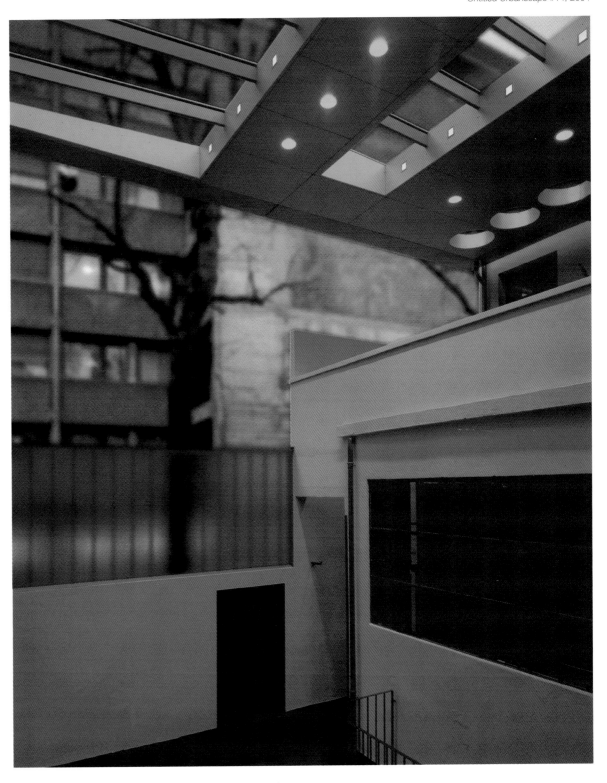

MATTHIAS BRUGGMANN

Switzerland, b. France 1978
Ecole d'arts appliqués Vevey, Switzerland,
2000–2003

Within the context of his work as a war photographer, Matthias Bruggmann wanted to explore the theory and practice of reportage. To do this, he compared this genre of photography with other styles, and began to combine a wide range of references, from Roger Fenton to Robert Misrach. Sometimes, in order to leave no stone unturned, he also looked towards semiotics and art history. These concerns are apparent in his treatment of recent events in Iraq and Haiti. A very contemporary self-referentiality can be seen in Bruggmann's objective, which is to operate in two registers at the same time: combining the representation of an event by photojournalism with the representation of photojournalism by the photographer.

Former Haitian senator Dany Toussaint explaining that Jean-Bertrand Aristide's Fanmi Lavalas ruling party manipulated the American Drug Enforcement Administration into believing that he was a drug trafficker. Dany Toussaint is barred from entering the US as a suspect in the murder of journalist Jean Dominique. From the series *Haiti*, 2004

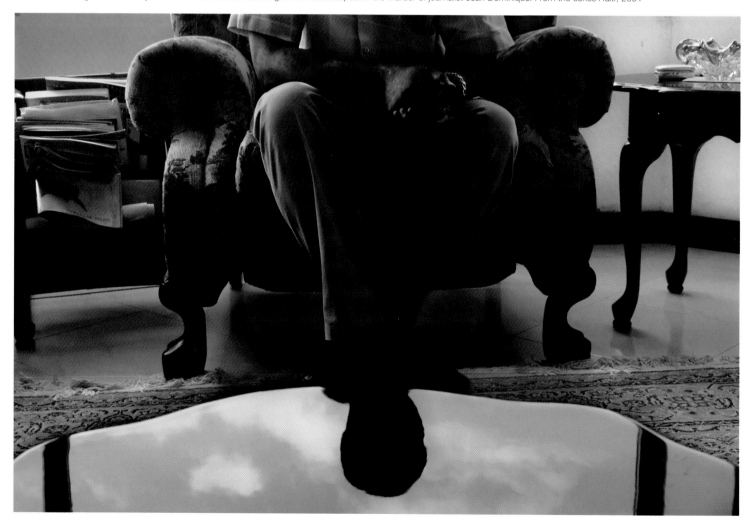

L. Paul Bremer III, the US Presidential Envoy to Iraq, prepares his weekly address to the Iraqi people. His nickname is Jerry, and some of his aides have titled him CEO of Iraq. From the series *Iraq*, 2003

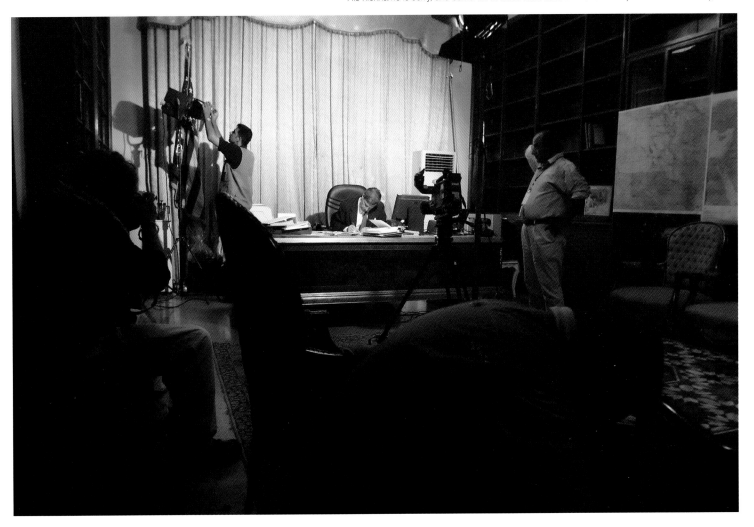

On Highway 80, the direct road from Kuwait City to Basra which was nicknamed the 'Highway of Death' after the first Gulf War, the British search Iraqi refugees who have fled Basra and are now trying to return. From the series *Iraq*, 2003

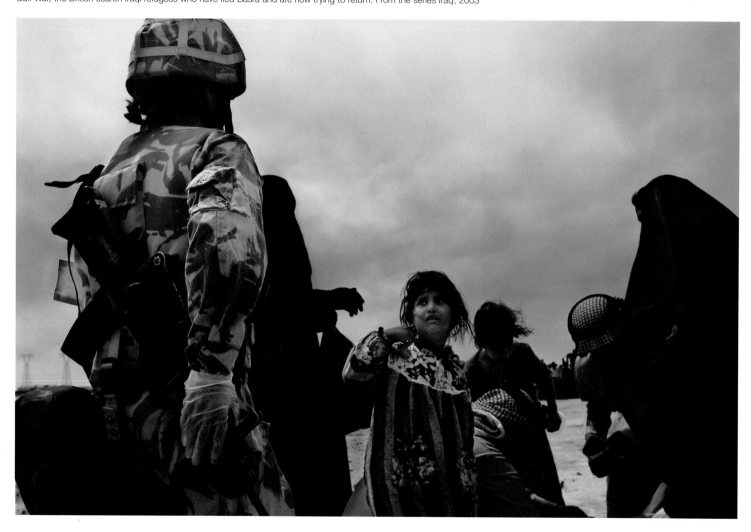

Near Basra's Technical Institute, a position used in attacks against British forces, the cousins and mother of a fallen Iraqi fighter claim his body. From the series *Iraq*, 2003

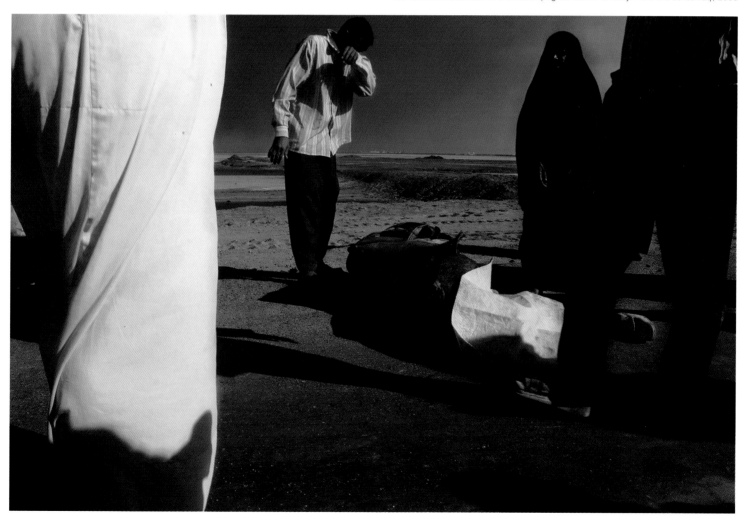

BIANCA BRUNNER

Switzerland, b. 1974
London College of Communication, England,
2002–2004
Royal College of Art, England, since 2005
Hochschule für Gestaltung und Kunst Zürich,
Switzerland, 1997

The photographic work of Bianca Brunner is based
on memory. The series *Limbo* explores the idea of
somatic memory, the body's own memory. The series
shows people fixed in motion, in a moment of
stillness. Nothing in the images is moving; everything
is held in a prolonged state of waiting. The artist
wants us to remember that human beings do not
only remember things with their minds, but that
many memories may be held inside the body. Her
second series, *Hotel Vacation*, also examines the
subject of memory, but this time the memory of
places. The photographs taken in deserted hotels
are references to a time gone by. An atmosphere
of mystery emanates from these spaces, which are
stripped of all human presence. Following the
photographer as she walks around the abandoned
building, viewers can imagine scenes that might
have taken place there. Usually, photographs only
show what is visible, but what is most apparent in
the work of Bianca Brunner is the invisible. Her
images are haunted by what is absent, the past
suddenly becoming a more tangible reality than
the present.

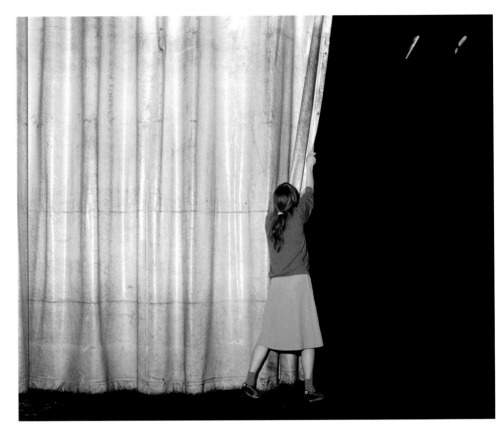

From the series *Limbo*, 2004

From the series *Hotel Vacation*, 2004/2005

From the series *Hotel Vacation*, 2004/2005

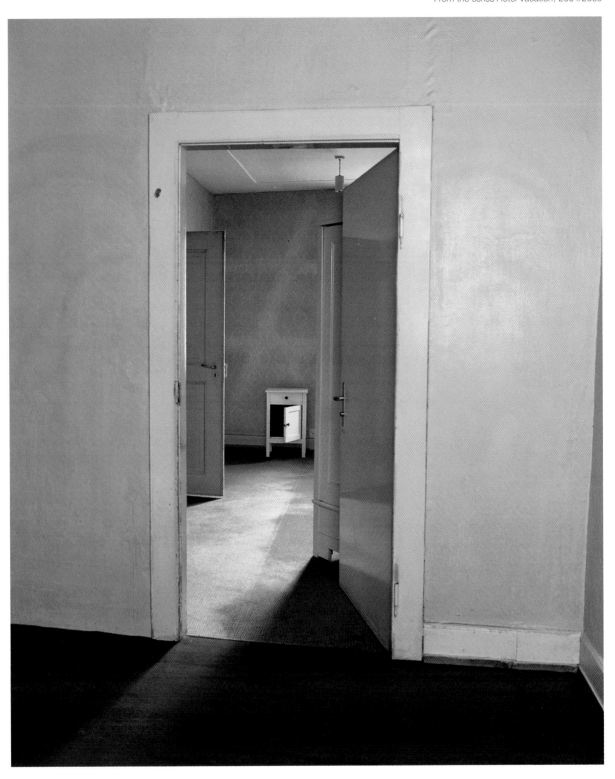

SONG CHAO

China, b. 1979
Beijing Film Academy, China, since 2004

Song Chao used to work twelve hours a day as a miner before taking up photography, which he did in 2001. Entirely self-taught, he began by photographing his fellow mineworkers during their breaks, isolating them in front of a neutral background, strictly framed, and so developed a style that focuses the attention of the viewer on his subjects' faces. Splitting his time between the mine and photography, he made several journeys to Beijing – 300 miles away from the province of Shandong in northern China, where he lives – in order to get advice on his new profession. Without ever thinking of photography as a means of passing social or political judgment, Song Chao built up a unique body of work – first in black and white, then in colour – that paints a portrait of the working classes in contemporary China. In the series illustrated here, he captures his peers at work, accenting the environment around them. The images have an air of mystery, in which time seems to be suddenly suspended. The subjects look directly at the photographer, and by extension at the viewer, awakening our curiosity about a people that even today remain an enigma to most Westerners.

Peng Ding, 26 years old, a drummer in a performing company, has been living there for 17 years with a salary of 800–1000 yuan a month. From the series *Residents in a Coalmining Area*, 2004

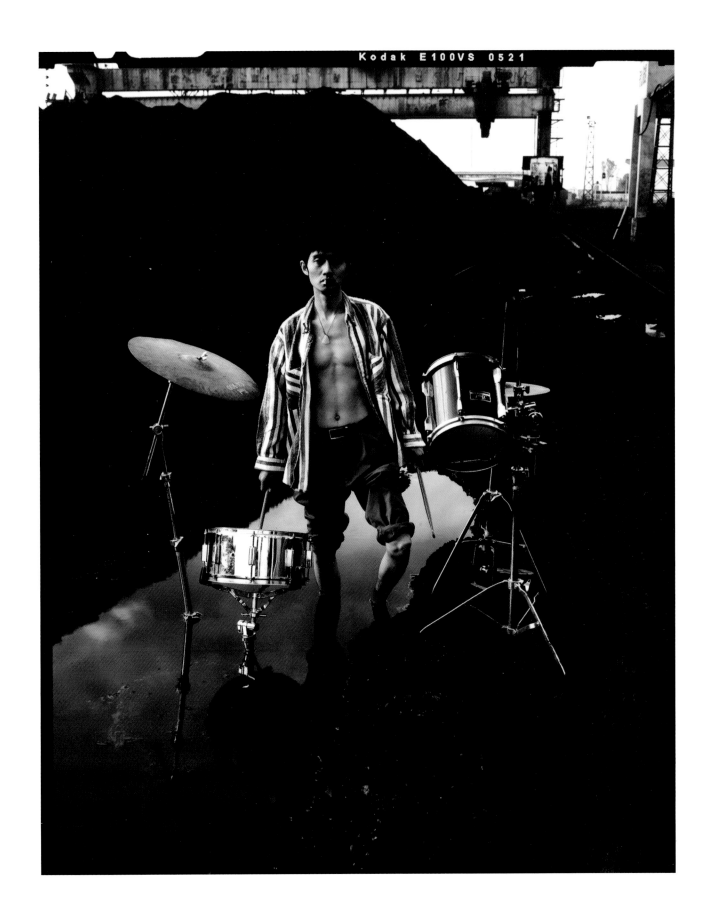

Kodak E100VS 0521

Xianwen Shi, 40 years old, a teacher, has been teaching there for 20 years with a salary of 1500–2000 yuan a month. From the series *Residents in a Coalmining Area*, 2004

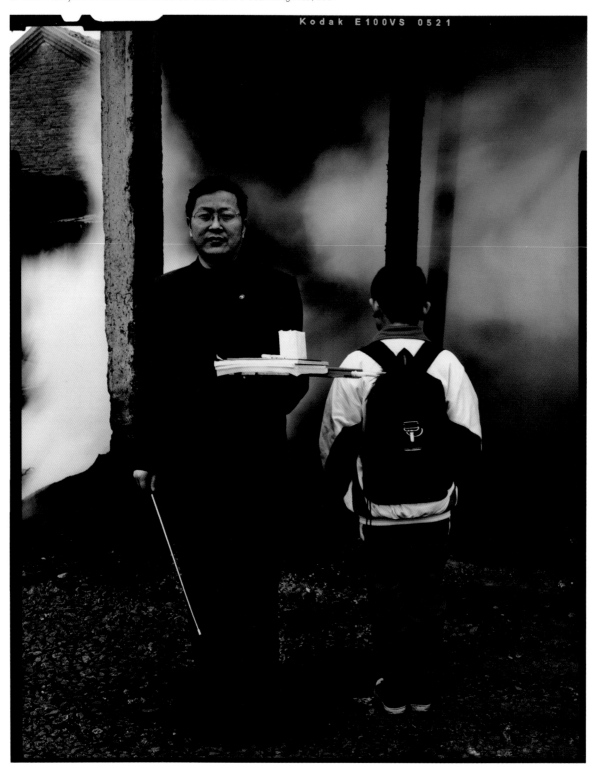

Lao Meng, 42 years old, a bicycle repairer, has been living there for 20 years with a salary of 1000 yuan a month. From the series *Residents in a Coalmining Area*, 2004

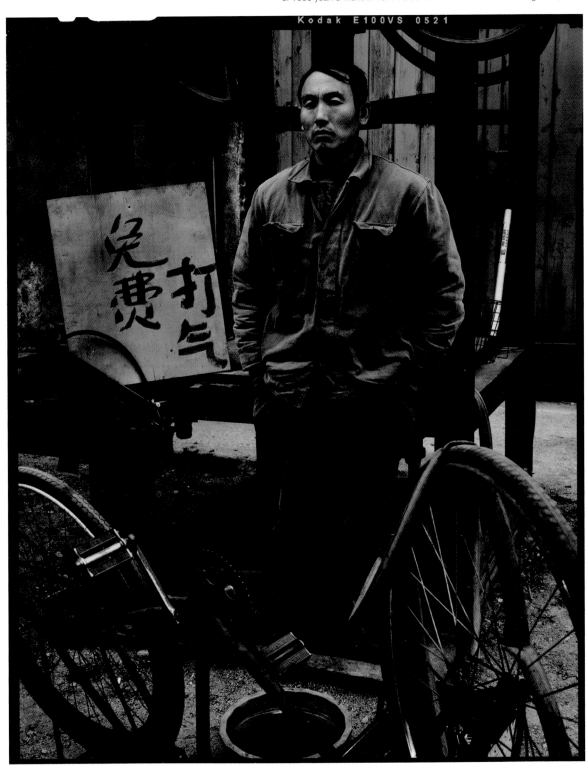

NATALIE CZECH

Germany, b. 1976
Kunstakademie Düsseldorf, Germany, 2000–2005

Two projects by Natalie Czech have tackled the
subject of the environment. In the series *Blattschnitte*
[Sheetlines], she began to work with negatives taken
from the Land Registry of the Federal Republic of
Germany. Wanting to show the changes that have
occurred in industrial and urban areas, she used
photographs taken at different times, in colour or
in black and white, which she then superimposed
on top of each other, copied, or reproduced in
multiple versions. She finds endless fascination in
showing how photographs from different sources
can be integrated into a single image, without it
being possible to tell the original source. In the
series *anderswo* [elsewhere], she examined the fate
of entire villages that, in being destroyed to create
open-cast mines, have been sacrificed at the altar
of industrial growth. The images are testament to
the violence of this transformation.

Untitled. From the series *anderswo*, 2001

Blattschnitte 13, 2004

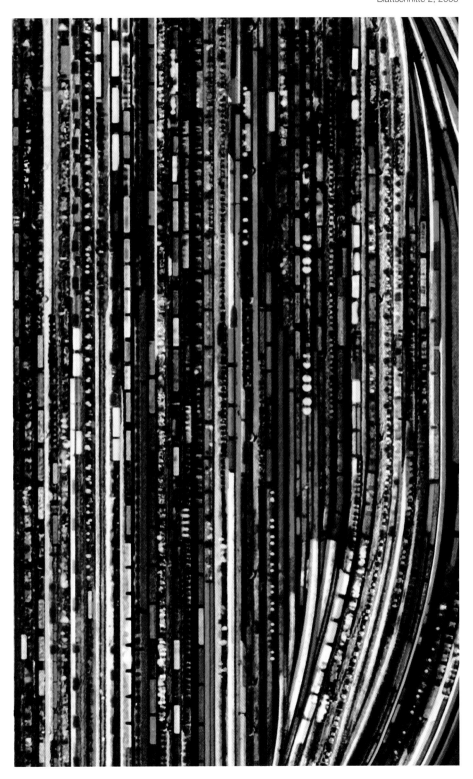

RAPHAËL DALLAPORTA

France, b. 1980
Les Gobelins, France, 2000–2002
Fabrica, Italy, 2002–2003

Anchoring his work in the strictest form of documentary photography, Raphaël Dallaporta examines man-made objects with shapes and variations that he finds fascinating. Each of his series occupies him for a long period of time. Since 1998, a section of his work has been devoted to landmines. These horrific objects are shown actual size, studio-photographed against a black background that makes the contours, colours and materials stand out. Paradoxically, the mines begin to resemble objects of desire, but this impression is swiftly shattered when we read the detailed captions that describe them – names, origins, specific uses. Photographed like advertising images, Dallaporta's landmines somehow appear seductive to those who view them, arousing feelings that range from fascination to repulsion.

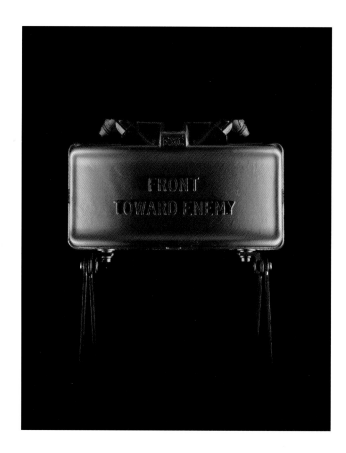

M18A1, 'Claymore', USA
Weight: 1.58kg Diameter: 35mm
Length: 216mm Height: 82.5mm
The 'Claymore' directional fragmentation mine releases 700 steel balls when it is detonated by a hand-turned dynamo or tripwire. (Multiple Claymores can be linked together using a detonator cord.) A 1966 field army manual states that 'the number of ways in which the Claymore may be employed is limited only by the imagination of the user'. In September 2002, Claymores made up 403,096 of the 10,404,148 landmines stockpiled by the USA. From the series *Antipersonnel*, 2004

opposite:

BLU3-B, USA
Weight: 785g Diameter: 140mm Height: 180mm
On release from a CBU-2C/A bomb, this 785g submunition – known as the 'Pineapple' – is stabilized and slowed in its descent by six fins. Each CBU-2C/A contains 409 BLU3-Bs, of which nearly 25 per cent do not explode on impact. It is impossible to defuse them. From the series *Antipersonnel*, 2004

SB-33, ITALY
Weight: 140g Width: 85mm Height: 30 mm
A scatterable blast mine, the SB-33 is resilient and completely waterproof. Its 35g explosive charge will result in the mutilation of the limb that detonates it. The SB-33AR version of the mine contains an anti-handling mechanism, but once laid is indistinguishable from the SB-33. The mine – no longer in production – was used in Iraq, Afghanistan and the Falkland Islands. From the series *Antipersonnel*, 2004

GMMI 43, GERMANY
Weight: 1.2kg Diameter: 85mm Height: 30mm
Used by Nazi forces during the Second World War, this antipersonnel mine has a glass construction and chemical fuse that render it undetectable. Glass fragments – which enter the body after the mine is triggered by pressure on the interior glass plate – are undetectable by X-ray. Colombian government sources say that homemade glass mines are being used by guerrilla forces in the country. From the series *Antipersonnel*, 2004

B-40, USA/VIETNAM
Weight: 700g Diameter: 60mm Height: 130 mm
The B-40 antipersonnel mine is a Vietnamese adaptation of American BLU-24B submunition. When activated, this homemade mine contains enough explosive and fragmenting pieces to blow off a leg. Despite the destruction of four million mines and eight million items of unexploded ordnance since 1975, it is estimated that 16,478 million square metres of land in Vietnam are still contaminated by mines. From the series *Antipersonnel*, 2004

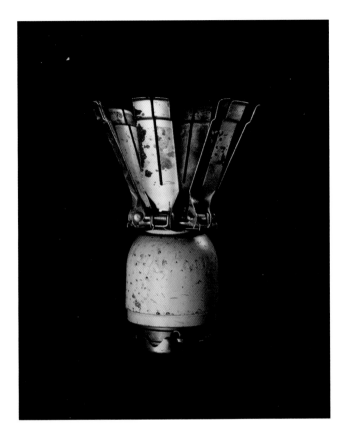
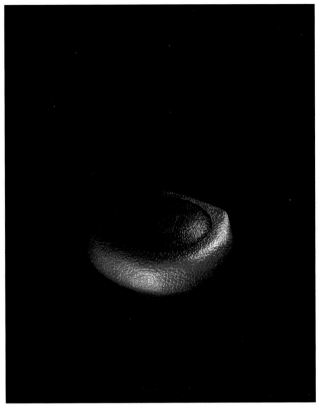
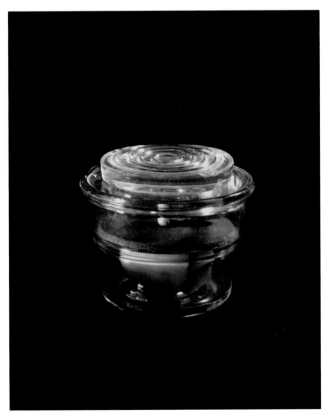
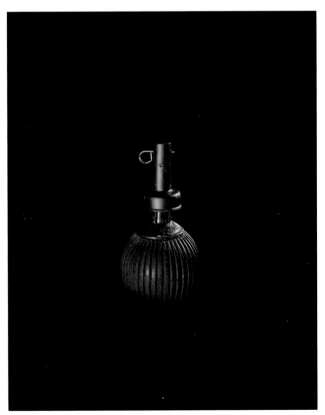

Saint-Sulpice, Paris, 6th arrondissement. From the series *Organs*, 2005

Saint-Roch, Paris, 1st arrondissement. From the series *Organs*, 2005

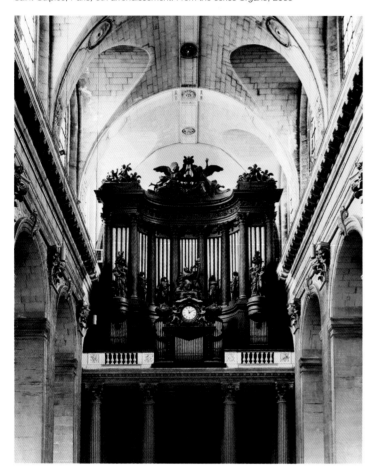

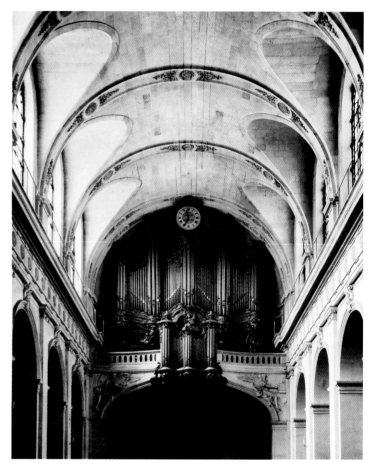

Sainte-Elizabeth, Paris, 3rd arrondissement. From the series *Organs*, 2005

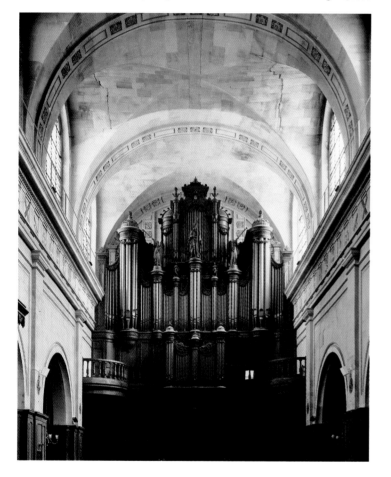

Saint-Etienne-du-Mont, Paris, 5th arrondissement. From the series *Organs*, 2005

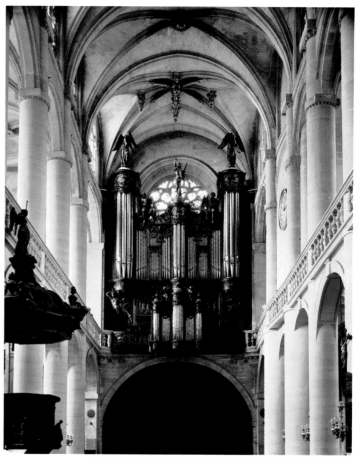

KATEŘINA DRŽKOVÁ

Czech Republic, b. 1978
FAMU, Czech Republic, since 2003

Kateřina Držková's landscapes question the
relationship between reality and representation.
Her work concentrates on the effect of duplicating
images and turning them around. Beginning with
the fact that a photograph is a flat representation,
she shows viewers something new by refusing to
imitate three-dimensional reality. She uses landscape
photographs taken frontally as raw material, and
subjects them to a long transformation process.
Using specific visual details of each image as a
departure point, she uses a computer to carry out
procedures such as reframing, duplicating, turning
and repeating. By placing it in a square format and
rendering it abstract with the use of the montage
technique, she makes the original landscape very
remote, and shows that a photograph, whether
it is a simple shot, a retouched image or a montage,
is nothing more or less than a representation and
the expression of its creator's vision.

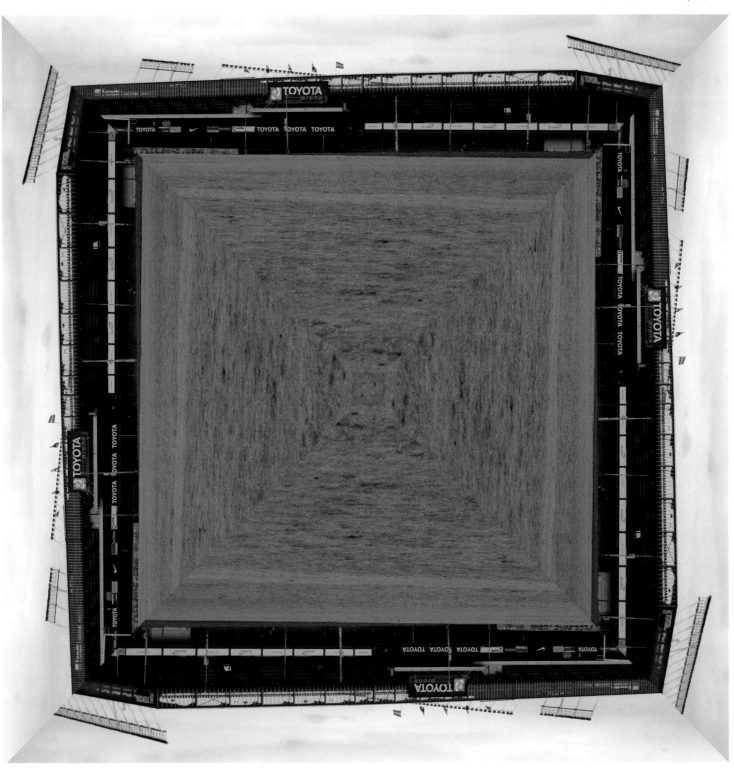

From the series *Landscapes*, 2004

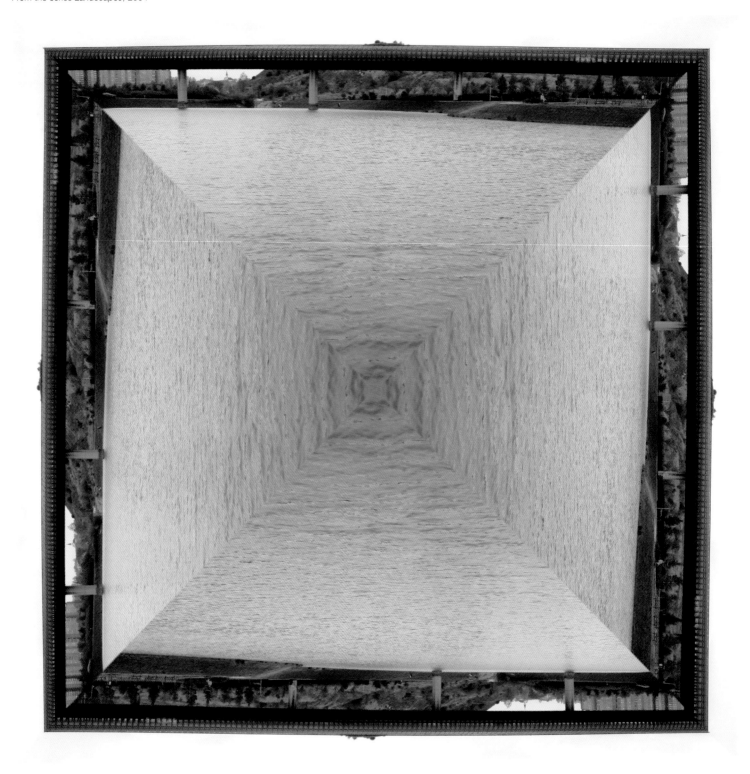

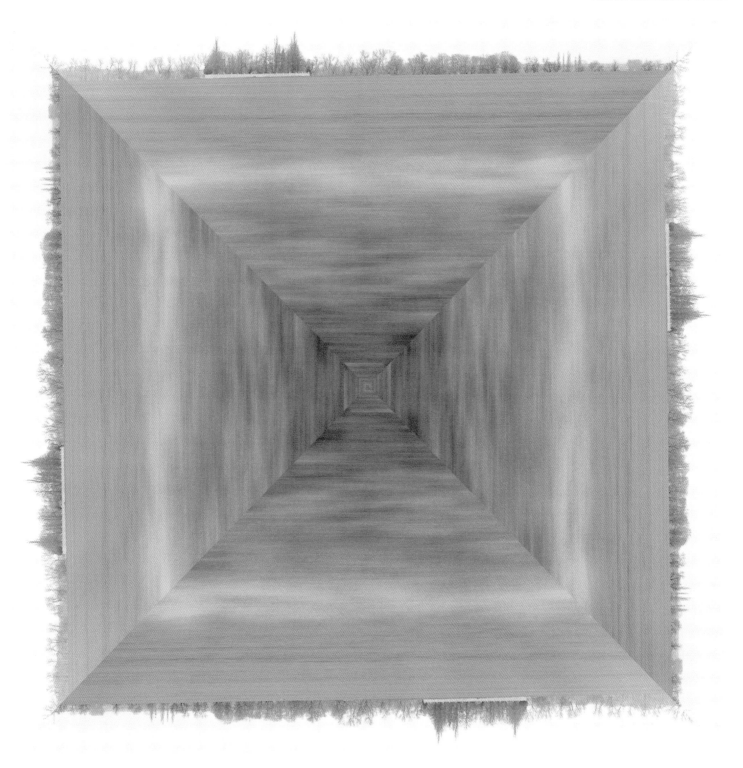

JULIE EDEL HARDENBERG

Greenland, b. 1971
Royal Danish Academy of Fine Art, Denmark,
1999–2000 / 2004–2005
Trondheim Academy of Fine Art, Norway,
1995–1999
Nordic Art School, Kokkola, Finland, 1995–1999

Born in Nuuk in Greenland, one of the smallest
capital cities in the world with 14,000 inhabitants,
in a land that has a population of only 55,000 but
is larger than Europe, Julie Edel Hardenberg did
a great deal of travelling – she studied in Finland,
Norway and Denmark – before she returned to
explore her own country. For a photography book
on the theme of cultural diversity, in summer 2003
she began a year-long journey to discover the far
north, visiting distant regions that are difficult to
reach. Her project took her to the north and the
east of the country, where there are communities
that live on fishing and hunting, and then continued
to the south of Greenland where extensive sheep
farming takes place. In this photographic travelogue,
Julie Edel Hardenberg observes at a distance the
daily lives of people who have made a home for
themselves in an inhospitable land.

51°W 70°N, April 2004

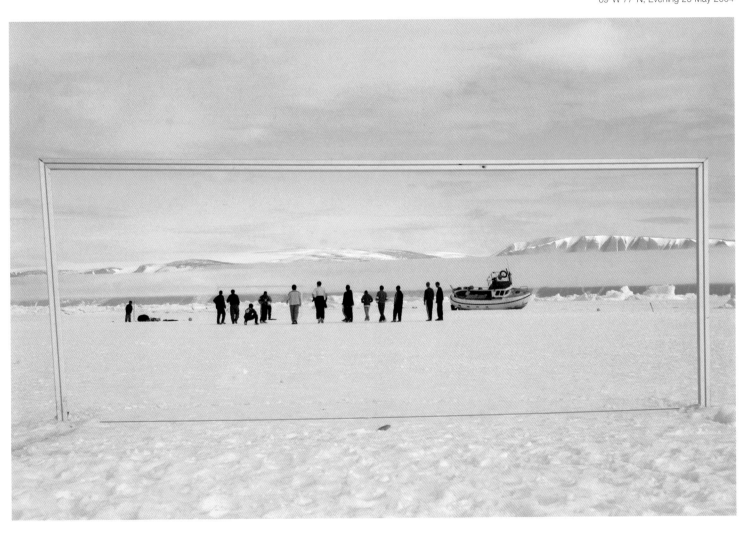

52°W 52°N, May/June 2004

LEO FABRIZIO

Switzerland / Italy, b. 1976
ECAL, école cantonale d'art de Lausanne,
Switzerland, since 2002

Leo Fabrizio's body of work is built around landscape.
Whether it is his series on bunkers – a collection of
four hundred photographs taken over a period of
more than four years – or his recent reportage work
in Bangkok, he focuses on fascinating man-made
creations that somehow make reference to the
natural landscape. In the series *Bunkers*, the military
installations are located in designated areas of land
or are camouflaged in the surrounding countryside.
In the series *Dreamworld*, the dynamism of the Asian
metropolis is expressed through sumptuous buildings
that dominate the natural world, which has been
crushed by the built environment. Leo Fabrizio's
subjects really do resemble stage sets. Completely
deserted, they seem to be the surviving evidence of
a show that is now over. The photographer, who
works in a large format to catch every detail, is
captivated by the constructions that human beings
have built to protect themselves, but in which
nature remains an ideal to be referred to.

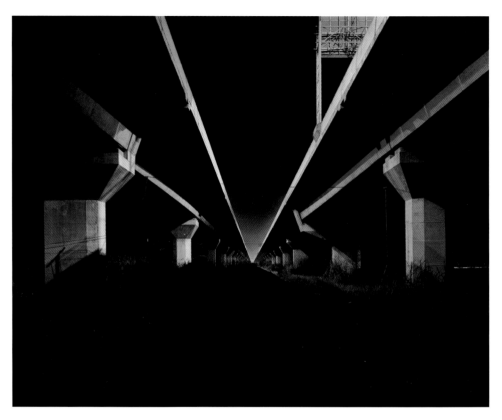

Highway. From the series *Dreamworld*, 2004

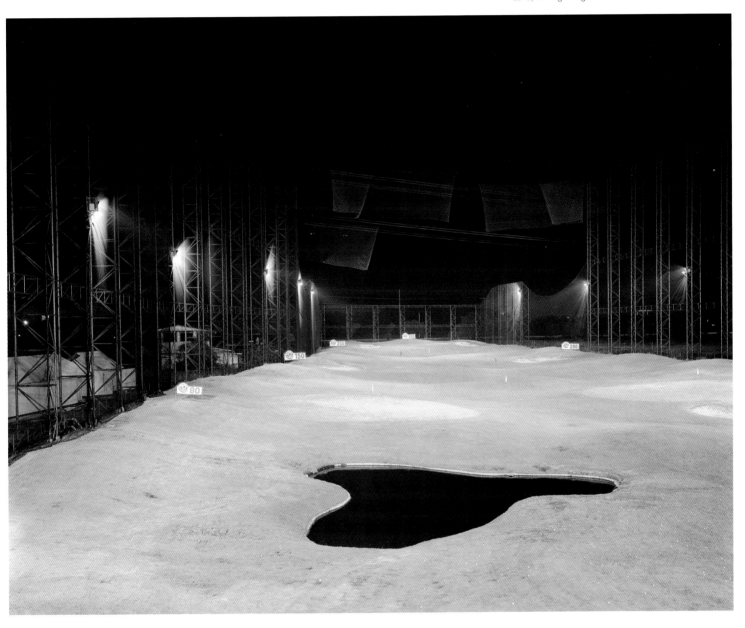

Fort Pré-Giroud, Vallorbe, Vaud, Switzerland. From the series *Bunkers*, 2000

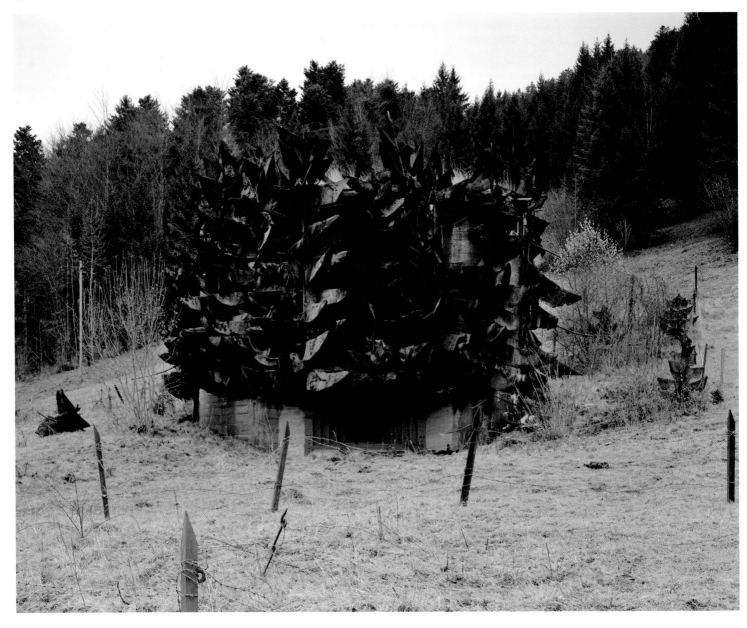

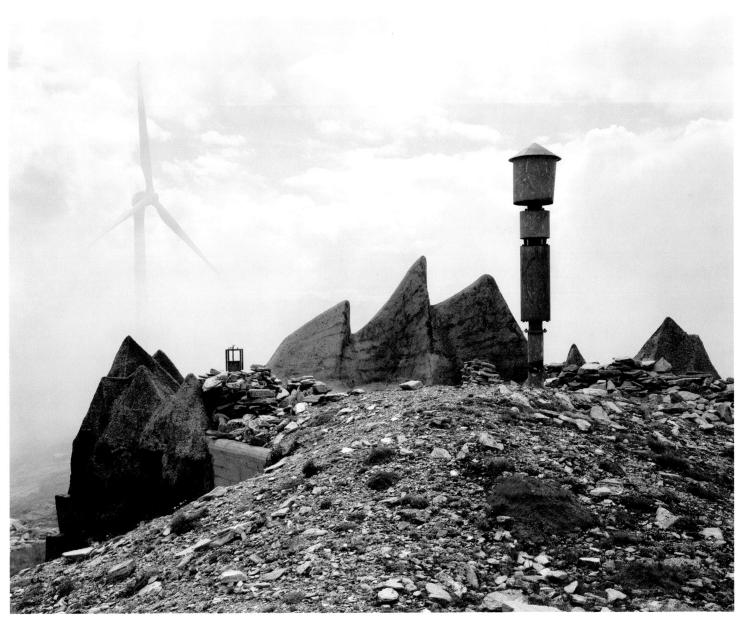

MIKLOS GAÁL

Finland, b. 1974
University of Art and Design Helsinki, Finland,
1999–2004
Högskolan för Fotografi och Film, Gothenburg,
Sweden, 1997–1998

By playing with focal distances, Miklos Gaál turns
scenes from everyday life into strange cardboard
cut-outs. City traffic, sporting events and parades
are all transformed into scale models. His
photographs, always taken from a distant and
elevated viewpoint, are disturbing to look at: the
fuzziness of some areas of the image creates a
curious effect of miniaturization, giving viewers the
impression of looking at an artificial toytown world.
Only by continuing to look carefully at the image,
orientated by the clearly focused areas of the picture,
can viewers pass beyond this first impression and
re-establish the truth. Gaál uses distance and
blurriness as ways of making the represented scenes
more remote and turning the tangible world into an
unreal universe. These images skirt the realms of
fiction, like the stories that children construct when
they simulate the real world in miniature.

Swimming Lesson #1, 2004

Swimming Lesson #2, 2004

Swimming Lesson #5, 2004

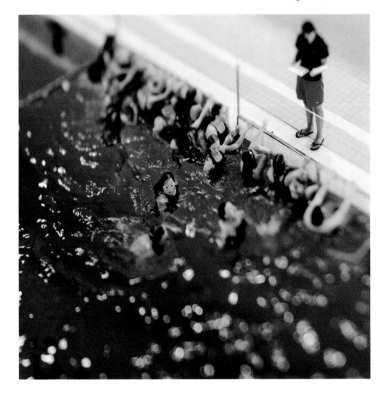

Event on a Commercial Street, 1999

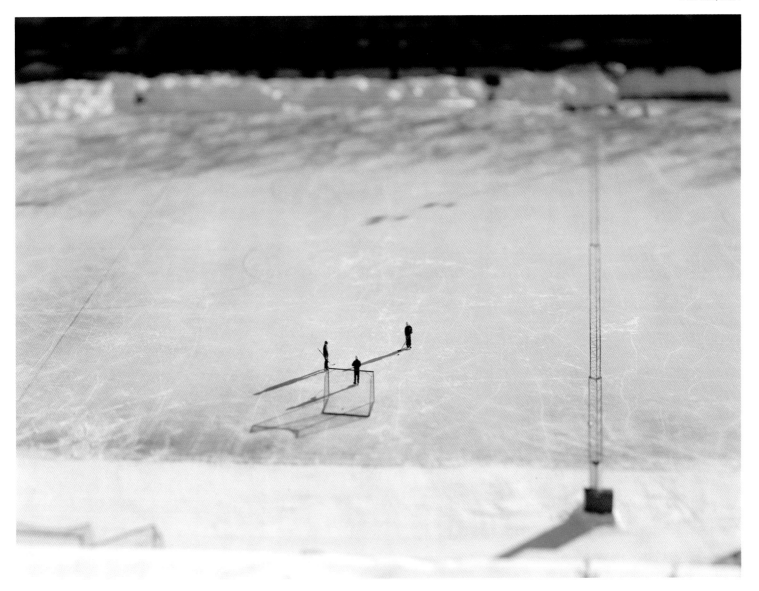

GÉRALD GARBEZ

France, b. 1973
Ecole Nationale Supérieure de la Photographie,
France, 2000–2003
Ecole des Beaux-Arts de Valenciennes, France,
1996–1999

Gérald Garbez's work includes landscapes, interiors
and portraits. Presented together, his photographs
weave a narrative thread, even though they depict
scenes that are devoid of action, in which time seems
to be standing still. Inspired by the novel *A Wild
Sheep Chase* by Haruki Murakami, Garbez builds a
set for the story by suggesting places through which
the characters of the novel might have wandered.
He then invites viewers to create their own story from
the world of the photographs, which therefore acquire
an autonomy from the novel that inspired them.

Untitled. From the series *An Intimate Fiction*, 2004

Untitled. From the series *An Intimate Fiction*, 2004

TARIK HAYWARD

Switzerland, b. 1979
ECAL, école cantonale d'art de Lausanne,
Switzerland, 2000–2003

Tarik Hayward's photographs evoke more than they represent, exploring the ability of photography to throw doubt on reality. The series *Bouzeland* is a collection of carefully and frontally framed images of objects of different scales, taken against an identical neutral background. Reproduced at the same size and printed on glossy paper, Hayward's photographs are highly sophisticated objects, in contrast with the subjects of the photographs, which come from the rural world. The photographer accentuates this disparity by depicting his subjects – a pile of manure, a pile of snow, a tree – like luxury objects. To do this, he borrows a technique from the world of advertising: using bright lighting to make the objects stand out from their surroundings, which are left in darkness. By using these different forms of artifice, Hayward creates a body of work with a strong sense of unreality, causing viewers to question the existence of the objects that are depicted.

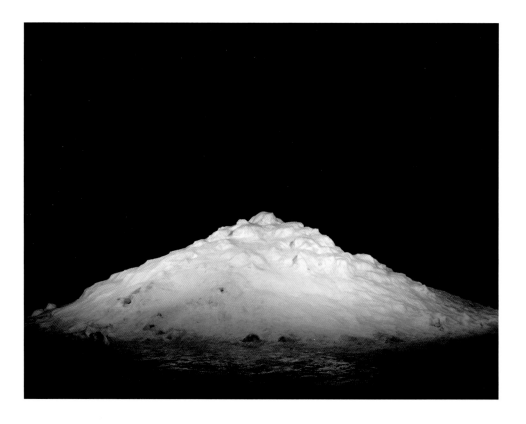

The Pile of Snow. From the series *Bouzeland*, 2003

The House. From the series *Bouzeland*, 2003

The Pile of Manure. From the series *Bouzeland*, 2003

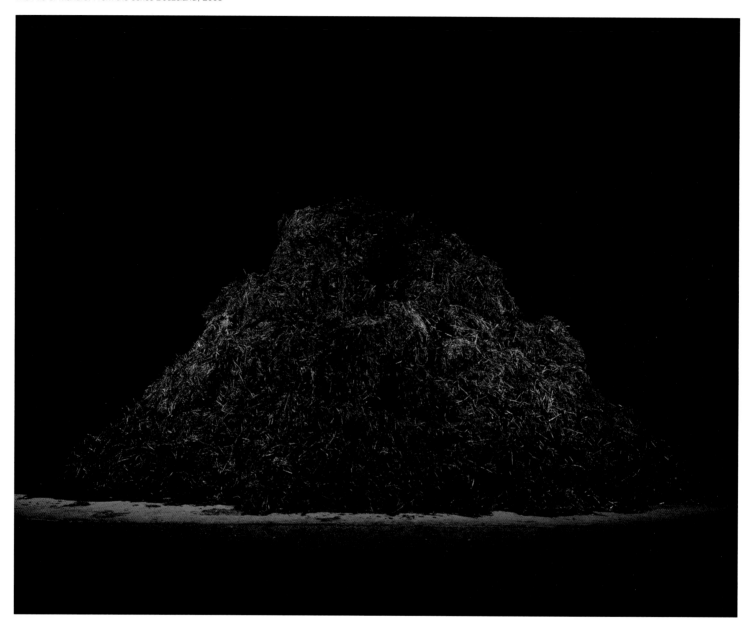

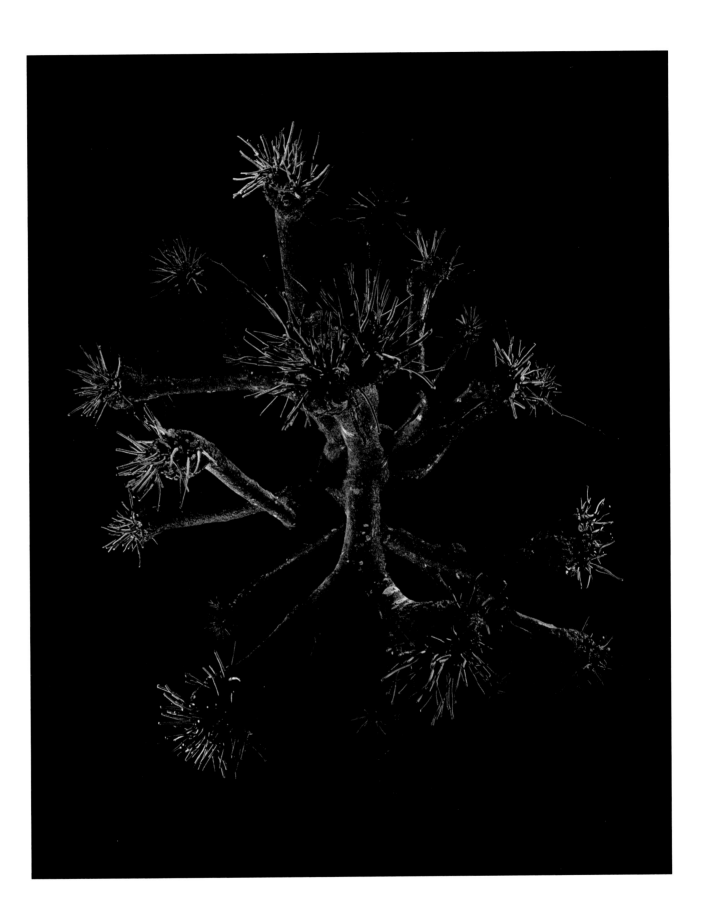

RAPHAEL HEFTI

Switzerland, b. 1976
ECAL, école cantonale d'art de Lausanne,
Switzerland, 1998–2002

Raphael Hefti found his models in department stores.
Choosing a frontal view, he wanted to capture in as
much detail as possible 'the face as an image' – a
concept that is further justified by the fact that the
women photographed all sell cosmetics and are
meant to represent the brand that employs them:
Clarins, Lancôme, Chanel, etc. Individuality
disappears behind a face that is coated in a layer
of foundation and blusher, reminiscent of a mask.
Hefti tells us that rather than faces themselves, we
should talk about the desire for a face. Make-up
and skincare products, visible in the background but
impossible to distinguish because they remain out of
focus, try to make us believe that we can all change
our faces and that it is possible to fight against time
and the body's own fragile nature. In its seductive
appeal but also sometimes in its excess, creating
a face means creating an image, as is eloquently
demonstrated by Hefti's portraits of saleswomen as
soldiers of consumerism.

From the series *Beauticians*, 2002

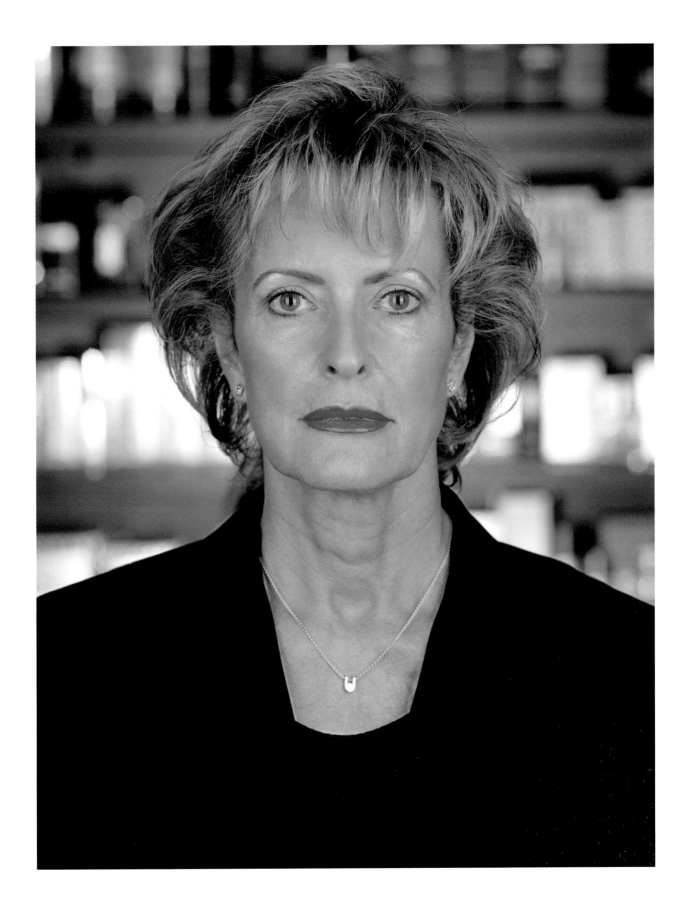

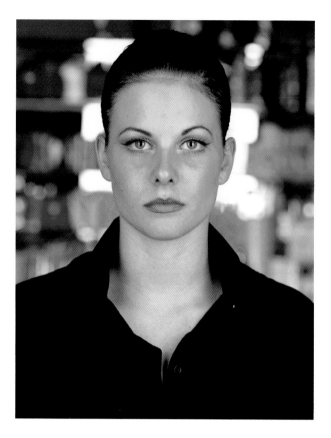

From the series *Beauticians*, 2002

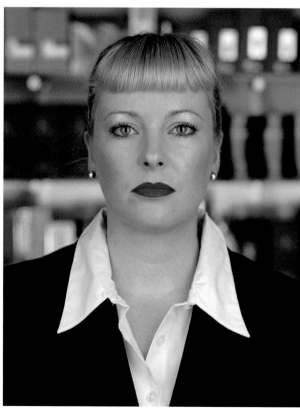

From the series *Beauticians*, 2002

From the series *Beauticians*, 2002

From the series *Beauticians*, 2002

AIMÉE HOVING

Netherlands, b. 1978
ECAL, école cantonale d'art de Lausanne,
Switzerland, 1997–2002

The society portrait, a very popular genre in painting, is revisited by Aimée Hoving, who uses photography to question its fundamental principles. Taking seated or standing portraits of people in their home environment, the photographer does not control the sitting herself and lets her subjects choose the background and the pose. She reduces herself to an observer and the photograph only reveals what the models want a representation of themselves to show. So, bourgeois young ladies dress as princesses and pose in their family living room under the watchful eye of their mothers, or lawyers allow their offices to be shown but take refuge behind their own desks. Nevertheless, the photographer does manage to reveal unexpected details about her subjects, who believe that they have control over the image that they are showing to the world.

From the series *Débutantes Ball, Paris*, 2003

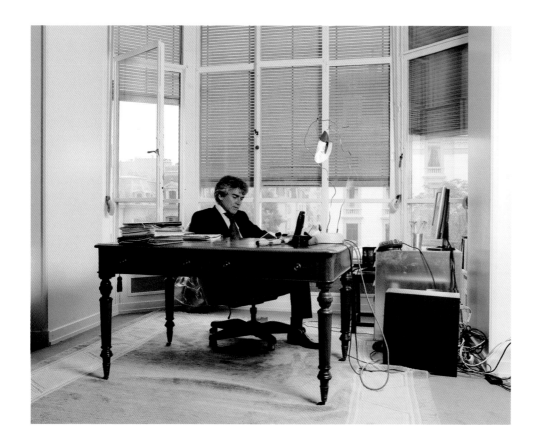

From the series *Deontologically Correct*, 2003–2004

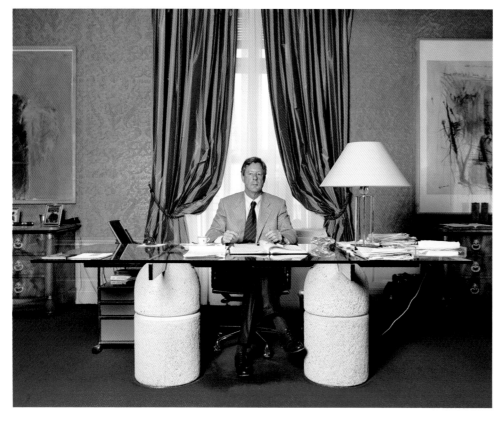

From the series *Deontologically Correct*, 2003–2004

From the series *Deontologically Correct*, 2003–2004

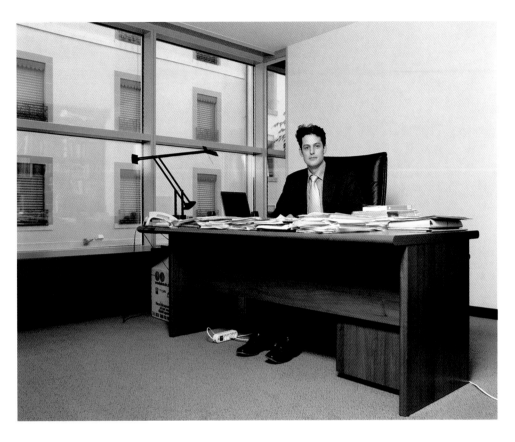

From the series *Deontologically Correct*, 2003–2004

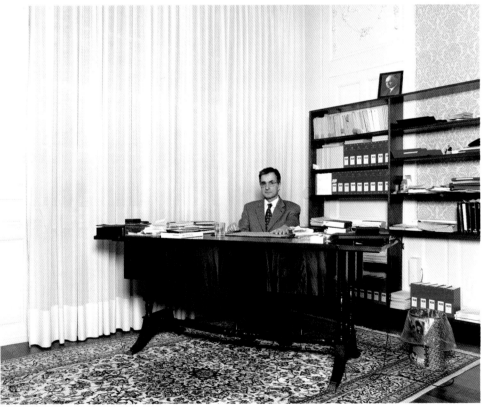

PIETER HUGO

South Africa, b. 1976
Fabrica, Italy, 2002–2003

Pieter Hugo is a documentary photographer with a particular interest in Africa and the developing world. In 2003 he began an enormous project during which he travelled to several countries in Africa, Europe and South America. In this series devoted to those with the condition of albinism, Hugo presents a frank and unflinching portrait of people who are often social outsiders. Even today, particularly in Africa, albinos are often considered to bring bad luck; alternatively, they may be idolized, their physical distinctiveness being seen as a sign of the presence of magical powers. Pieter Hugo's reportage was an attempt to rehabilitate the image of albinos and to observe how an identity defined only by physical difference can affect social position and have an impact on everyday life. With the photographer's use of close-up studio portraits in particular, the viewer must confront the subjects head-on, giving back to them what is so often denied: their humanity.

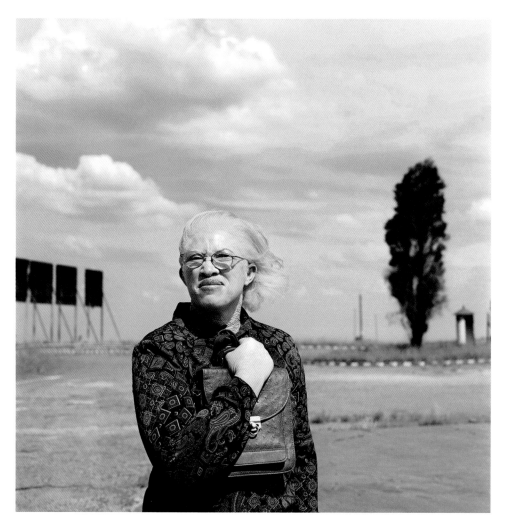

Vukiswa Tyami, Johannesburg, 2003

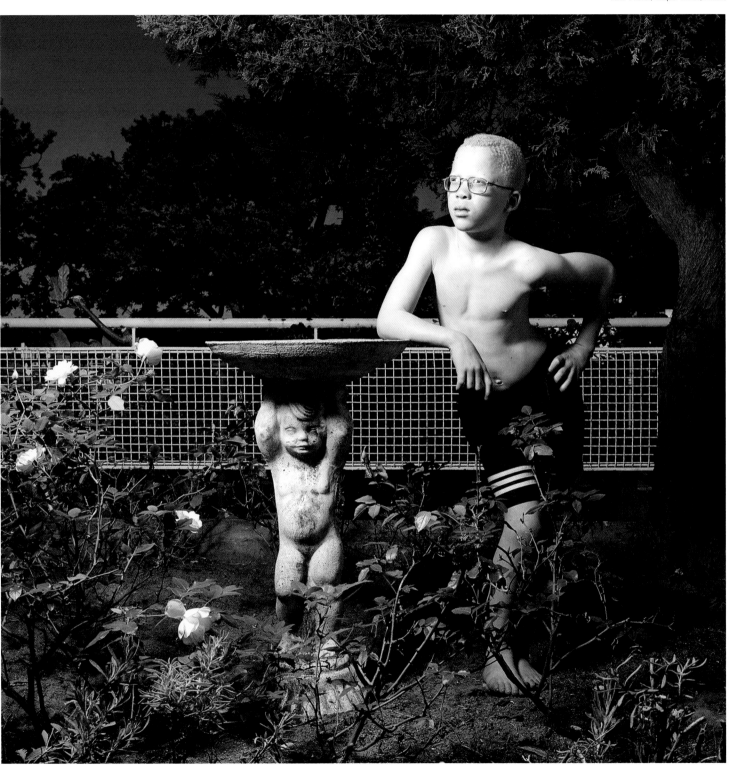

Vuyiswa Kama, South Africa, 2003

Steven Mohapi, South Africa, 2003

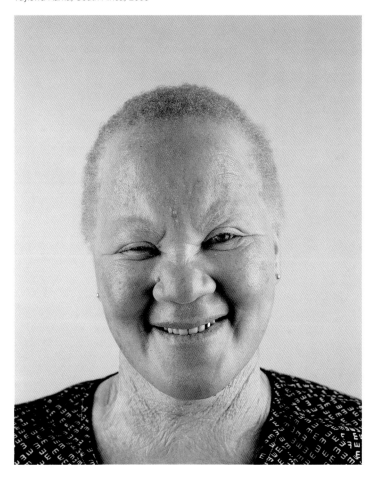

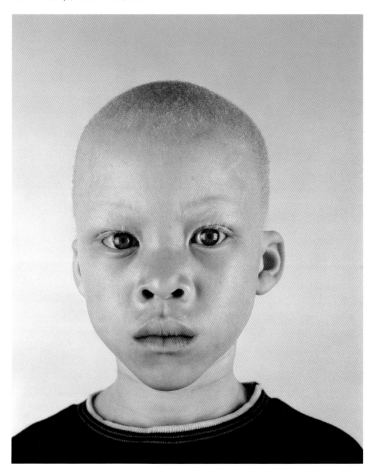

Thami Mawe, South Africa, 2003

Thembile Mabaso, South Africa, 2003

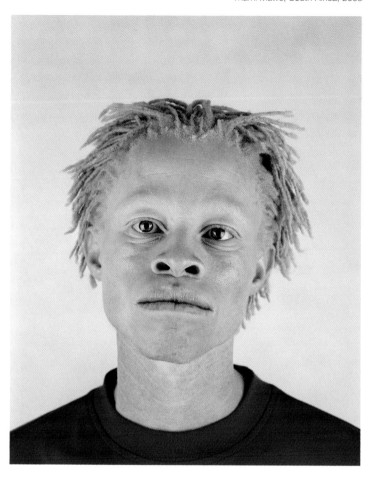

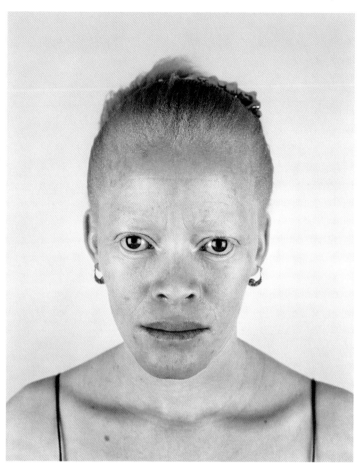

MILO KELLER

Switzerland, b. 1979
ECAL, école cantonale d'art de Lausanne,
Switzerland, 2001–2005

Milo Keller wants to share with us his interest in still
life, believing that the immobility of the subject
possesses the great advantage of allowing time for
reflection. This approach lets him turn his gaze on
objects on both a small and a large scale. Where the
latter are concerned, he is particularly fascinated by
oil tankers, dams, silos and tunnels. These go beyond
the human scale, their sheer dimensions aligning
them with the largest structures found in nature. It
makes sense, therefore, that Keller has taken a great
interest in the AlpTransit Saint-Gothard, the enormous
construction site of a new tunnel under the Alps,
which will be the longest railway tunnel in the world.
The photographer depicts a subject that he saw as a
huge model kit, with the machines becoming abstract
sculptures and the artificial lighting creating a strange
science-fiction atmosphere.

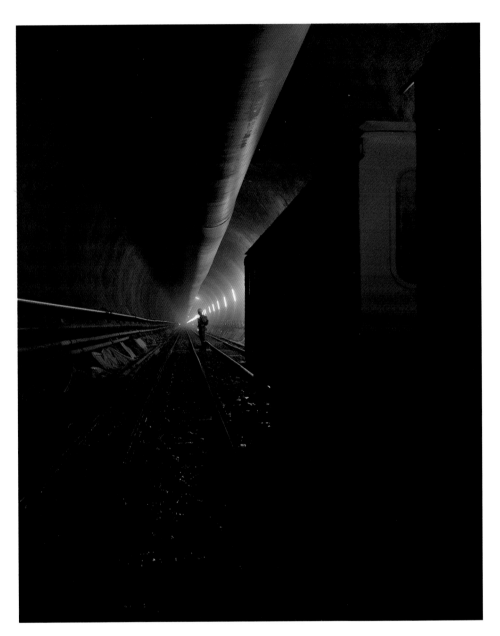

From the series *AlpTransit*, 2004

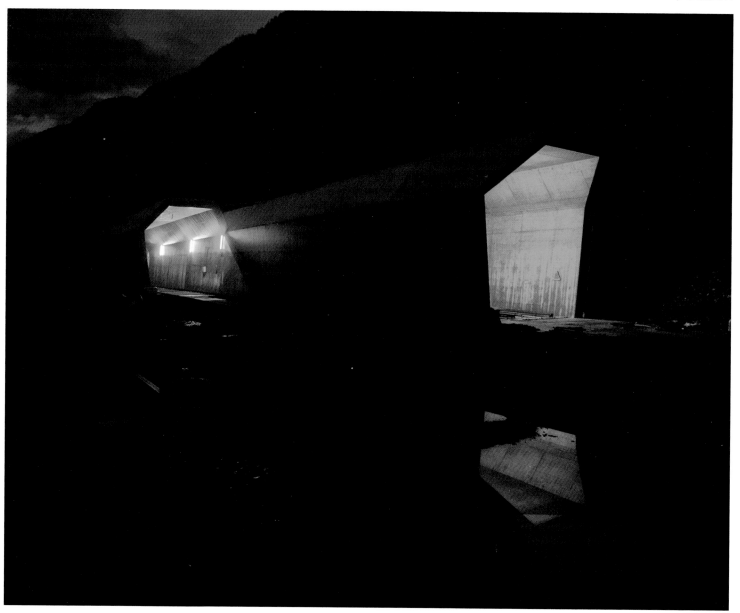

From the series *AlpTransit*, 2004

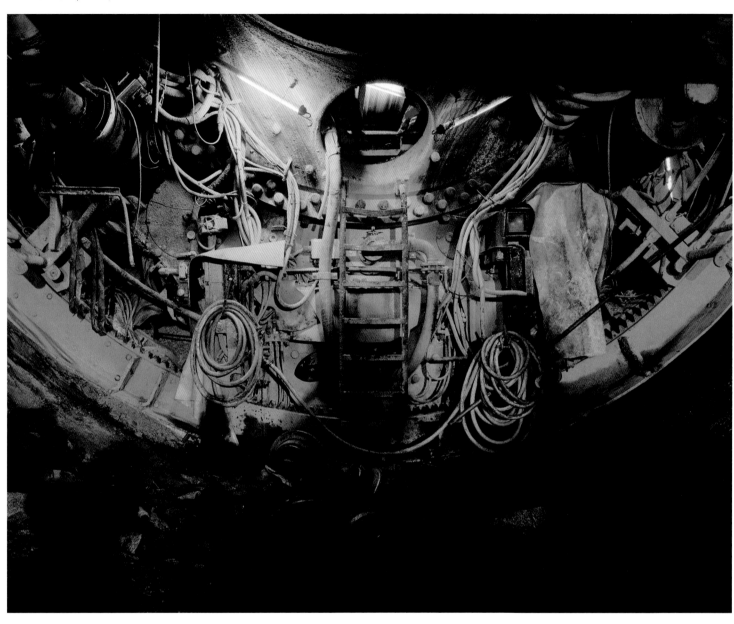

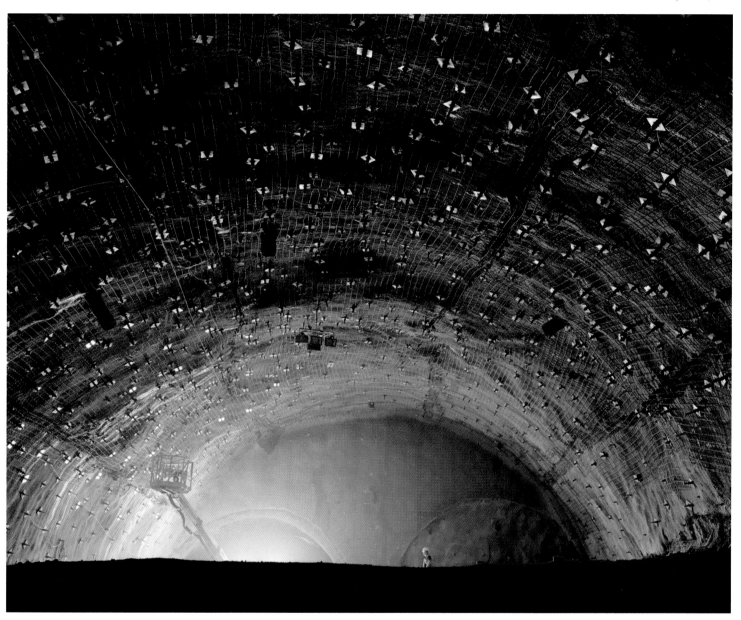

IDRIS KHAN

England, b. 1978
Royal College of Art, England, 2002–2004
University of Derby, England, 1998–2001

every... Page of Roland Barthes' Book
Camera Lucida, 2004

Idris Khan is fascinated by photography as a medium. Inspired by images and theoretical essays that have influenced the history of photography, he reappropriates the works that have affected him and subjects them to a series of transformations to see if they evaporate or lead to something new. The series *every...* presents these works – travel photos, photos by other photographers, pages of famous books – which Khan has re-photographed, enlarged and superimposed in multiple layers. Using digital technology he alters the opacity of the layers to reinforce the mystery of the original objects, while allowing their superimposition to reveal new details. As well as being an homage to photography itself, which is defined here as a compilation of knowledge, Idris Khan also establishes his own position within a field that is already loaded with the weight of history but is still, to Khan's mind, full of promise for the future.

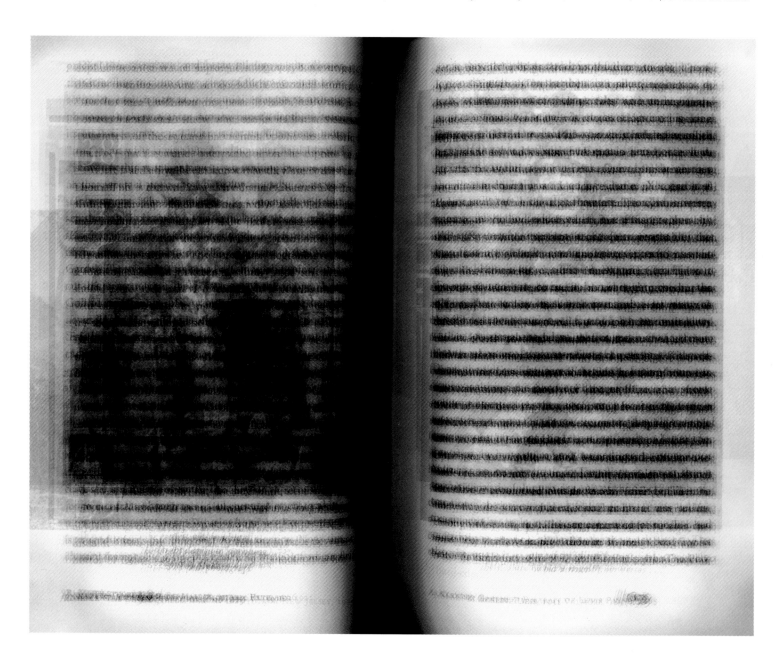

every... Photograph taken while travelling around Europe in the summer of 2002, 2003

every... Photograph taken from the top of the Empire State Building, 2004

GÁBOR ARION KUDÁSZ

Hungary, b. 1978
Hungarian University of Crafts & Design, Hungary,
1997–2003
Athens School of Fine Arts, Greece, 2001

Gábor Arion Kudász's images are the result of many
journeys throughout Hungary. Earlier visits to industrial
sites around the Mediterranean, and long hours spent
on Hungarian motorways in a haze of pollution, made
a strong impression on him: he is convinced that in
the name of development and progress Hungary is
losing its human qualities and its harmonious
relationship with nature. Kudász has chosen to
concentrate on murky urban settings, from which
he digitally removes all traces of human beings and
human activity. Kudász's Budapest emerges as a
deserted city, abandoned and imaginary.

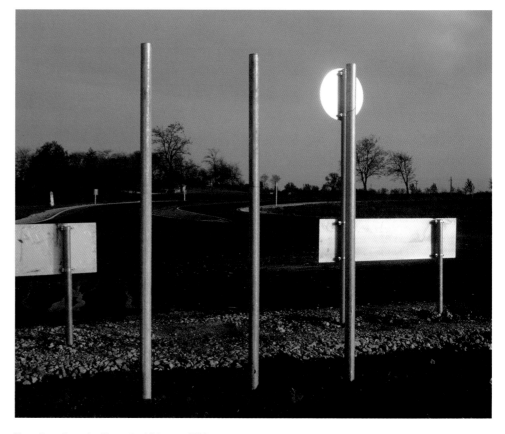

Ebes. From the series *Hungarian Highways*, 2003

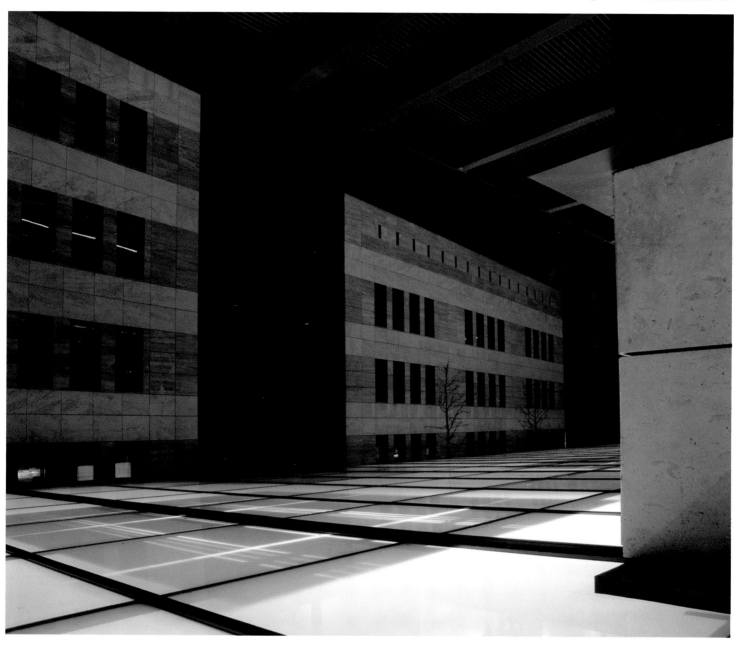

New York Café. From the series *Internation*, 2004

Kosztolanyi Dezso Square. From the series *Internation*, 2004

EVA LAUTERLEIN

Germany / Switzerland, b. 1977
Ecole d'arts appliqués Vevey, Switzerland,
2000–2003

Eva Lauterlein questions the idea of the face as a
sign of identity, the very pillar of traditional portrait
photography. Working in a 'cubist' style, she uses
a computer to build up portraits from different shots
of the same model, whom she has photographed
from different angles, sometimes combining up to
thirty different images. The result is unsettling to say
the least, because the metamorphosis is total and
yet barely perceptible. Depicting people who look
somewhat disturbing, skirting the edges of
monstrousness, Eva Lauterlein's photographs are
completely unimaginable before they are put through
morphing software. The portraits are so heavily
reworked that the models' identities are lost. The
chimera is created by reconstruction: the identity
becomes a face nonetheless, a face with a form
and solidity of its own, yet which at the same time is
unable to give any information about the personality
of the model who was originally photographed.

From the series *chimères*, 2002–2004

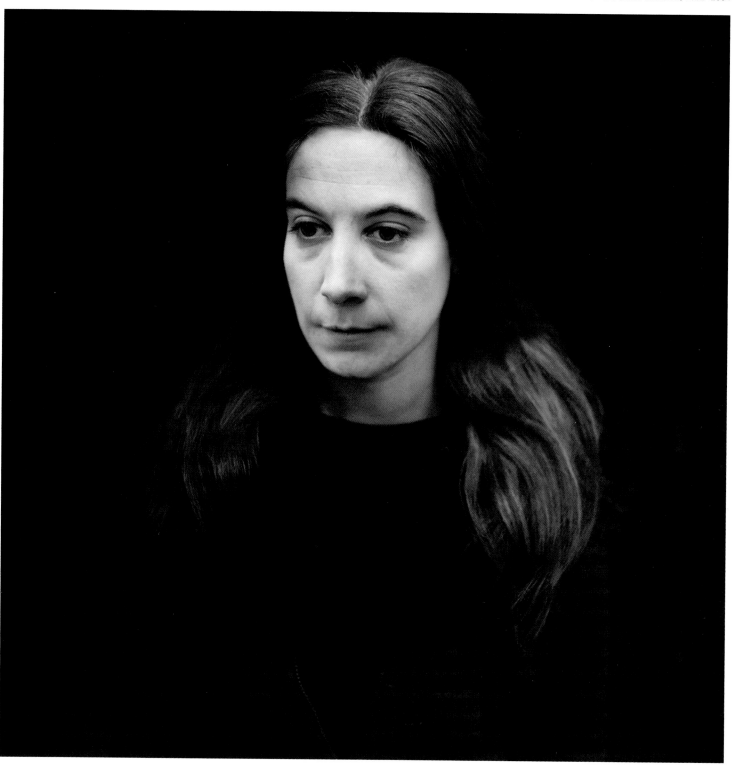

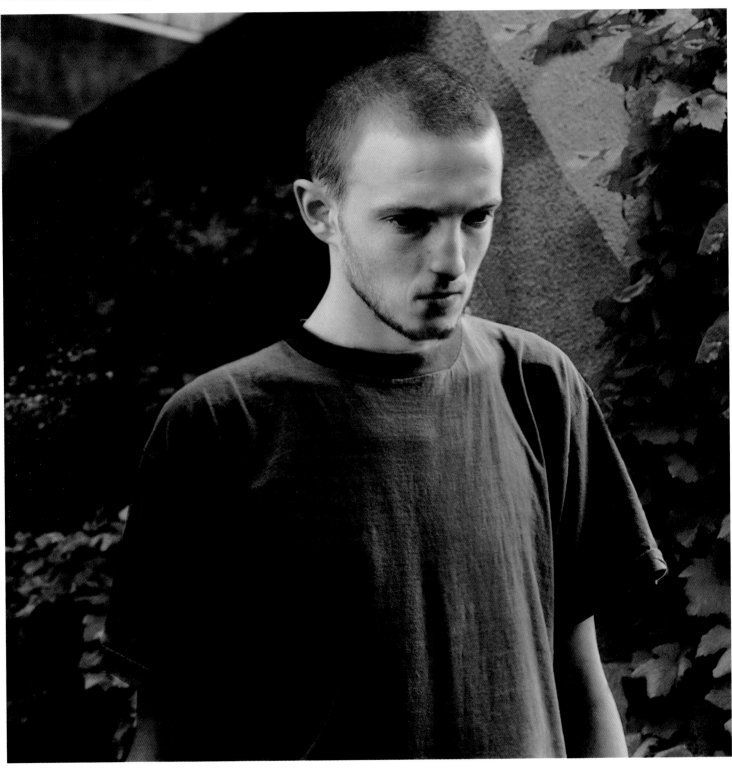

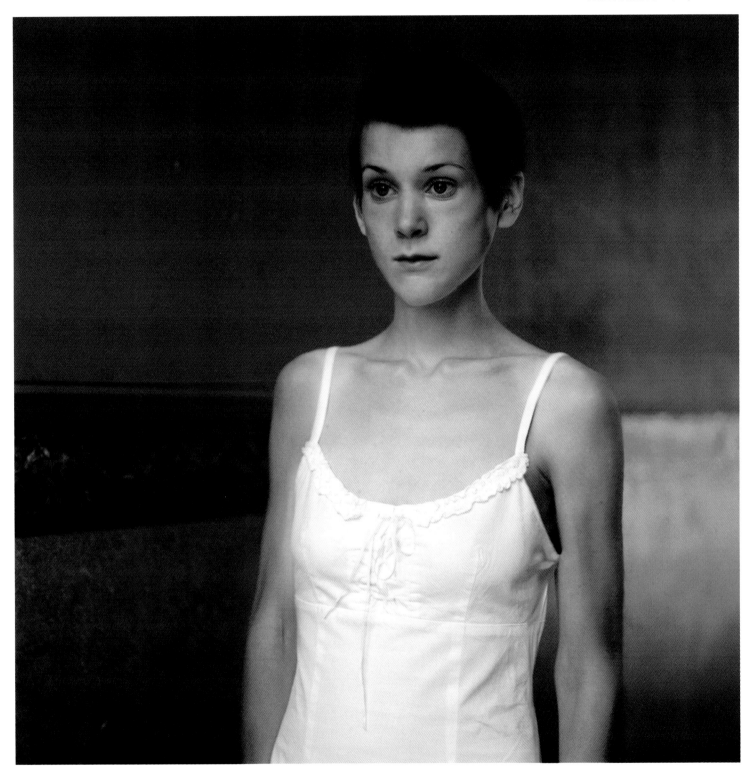

LUCY LEVENE

England, b. 1978
Royal College of Art, England, 2002–2004
Edinburgh College of Art, Scotland, 1997–2001

Lucy Levene watches her own generation. In 2001, she began to take reportage shots in a night club – a series that she continued until 2004 – to observe the behaviour of her contemporaries. The scenes that she photographed look exactly like scenes in a play in which the actors are exaggerating their movements to attract more attention. Although they were not aware that they were being photographed, Levene's subjects are nonetheless acting. They know that they are being watched. In this way, the photographer studies a generation for whom image is a part of everyday life. In the series *Marrying-In (Please God By You)*, she explores another aspect of her own culture: by photographing herself next to a young man with whom she maintains a physical distance – signifying a lack of contact – she wants to show the incongruity of the custom that dictates that Jewish people should intermarry. Brought up in a Jewish family, she is questioning the basis of a tradition that for her generation has become a means of cultural distinction, rather than a religion. In her work, Lucy Levene asks questions about the desire to maintain at all costs cultural distinctiveness within a multicultural society.

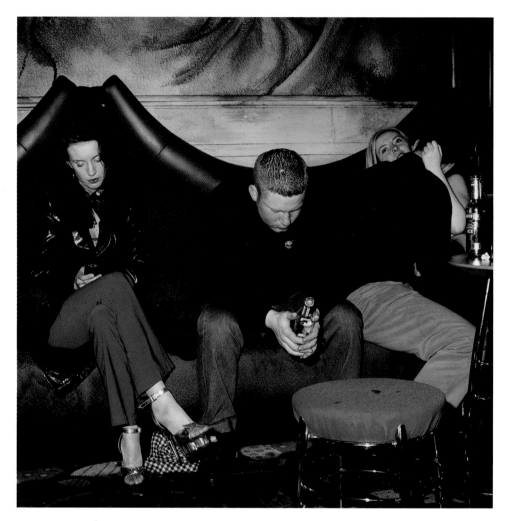

From the series *Come and Be My Baby*, 2001

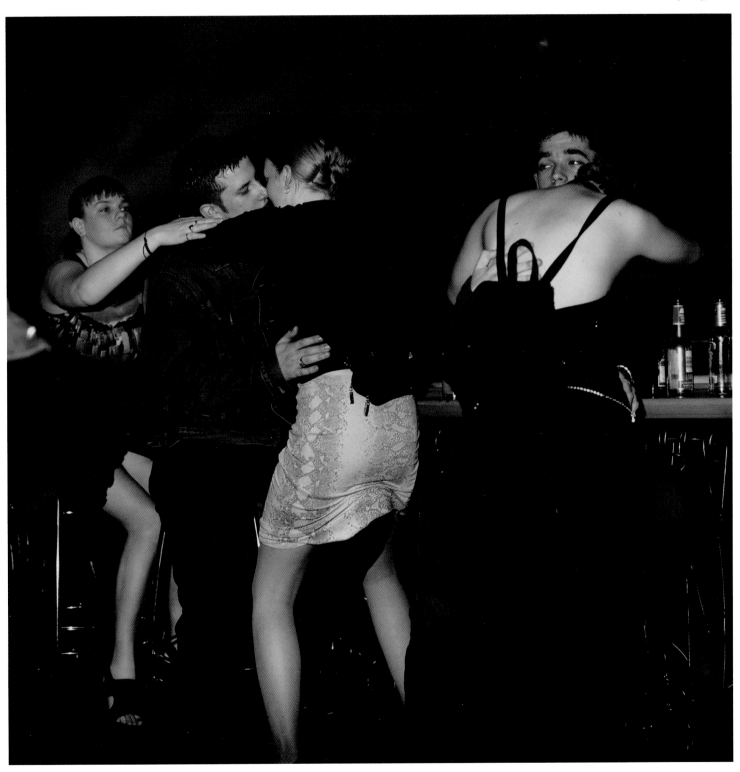

From the series *Marrying-In (Please God By You)*, 2001

From the series *Marrying-In (Please God By You)*, 2001

From the series *Marrying-In (Please God By You)*, 2001

From the series *Marrying-In (Please God By You)*, 2001

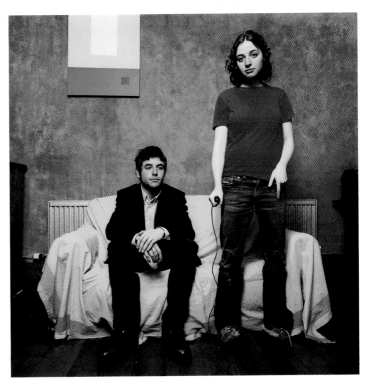

RÉMY LIDEREAU

France, b. 1979
Ecole Nationale Supérieure de la Photographie,
France, 2001–2004

Rémy Lidereau explores the way that photography
can float between fact and fiction. In an attempt to
create doubt in the viewer's mind, his images seem
to match reality yet at the same time contain small
clues that tip them into the realm of the unreal.
Taken with a 4x5 camera, which shows details in
high precision, the photos are then converted to
a digital format and manipulated by the artist.
Although photography has a longstanding tradition
of using models to simulate reality, Lidereau works
the other way around. His landscapes begin as
photographs but are reworked by computer in
whichever way his imagination dictates, becoming
the constructions of his own mind. Ultimately, it is
left to the viewer to detect the alterations that the
artist has made.

Puteaux, France, March 2004

Lahti, Finland, April 2003

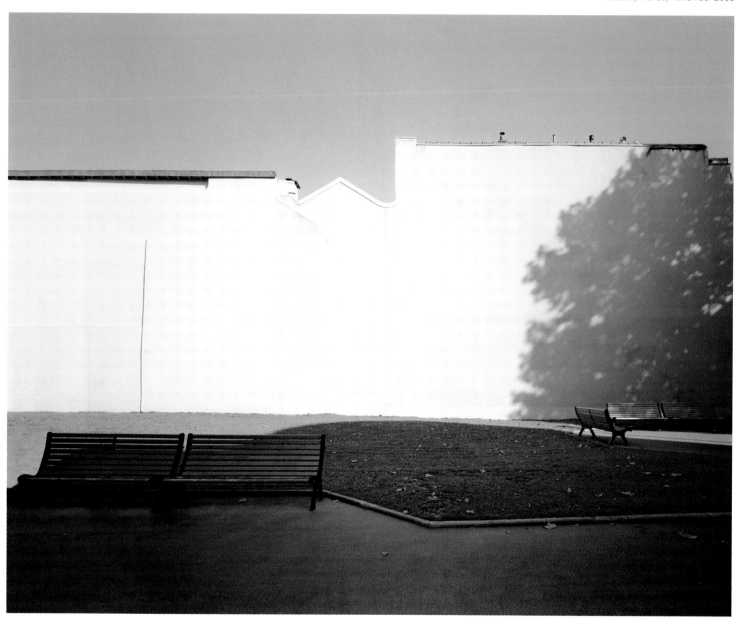

MARCELLO MARIANA

Italy, b. 1977
C.F.P. Centro Riccardo Bauer, Italy, 2003–2005

Marcello Mariana, like many of his contemporaries, lives in a large metropolis, Milan. As in most contemporary cities, it is a place where the sky is ignored. The built environment blocks the view and is often seen as oppressive and asphyxiating. In order to draw attention to the sky, which is absent from the daily lives of city-dwellers, the photographer takes an unusual look at the element that has allowed cities to rise vertically: the elevator. A closed box and a restricted space, the elevator is a place in which the eye's gaze is blocked. Often, at the moment when an elevator begins to rise, people glance up at the ceiling. Marcello Mariana's images depict a space that recalls not an ordinary elevator, but a spaceship in which the viewer seems to float due to lack of gravity.

Via Bottesini 13. From the series *ottovariazionisulcielo*, 2004

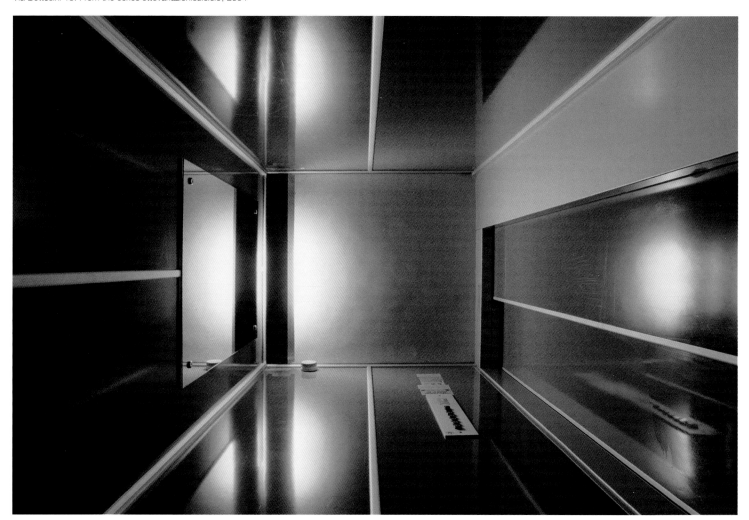

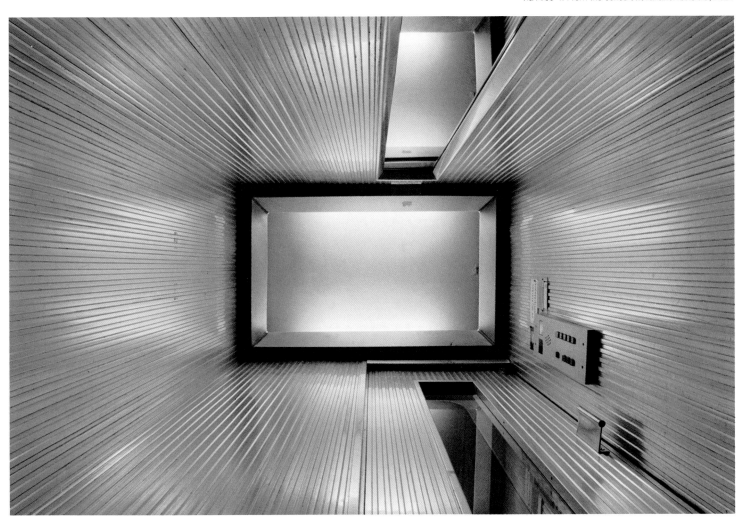

Viale Monte Nero 46. From the series *ottovariazionisulcielo*, 2004

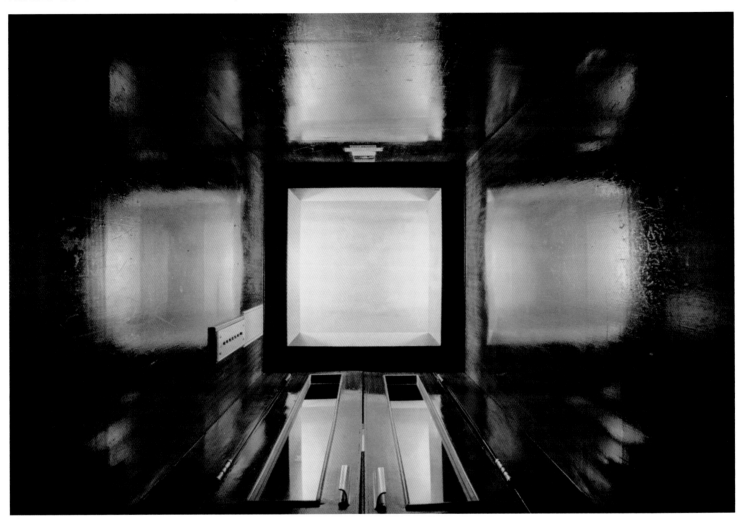

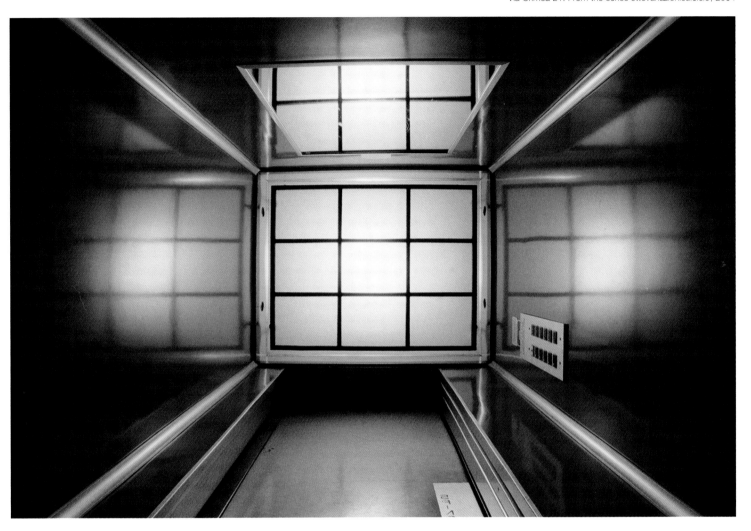

OREN NOY

Israel, b. 1975
Bezalel Academy of Art and Design, Israel,
2000–2004

Oren Noy is interested in objects from domestic life.
Reflections of the cultural and social class of the
people to whom they belong, these objects are
depicted in their usual surroundings and not idealized
in any way. In refusing to criticize the aesthetic of
these surroundings, the photographer simply
attempts to show the aesthetic conventions that
govern everyday life. Although they were taken in
Israel, his photographs could have been taken in
almost any working-class home in the Western
world. Noy deliberately adopts a style that resembles
amateur photography. He makes no attempt to
dramatize the scene or to capture the famous
'decisive moment'. He suppresses any natural light
in the image by using a flash. This has the effect
of flattening the photographed objects and making
them stand out, showing them as they appear in
an everyday context.

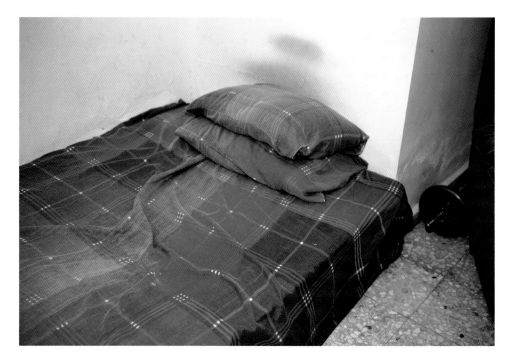

Untitled, 2004

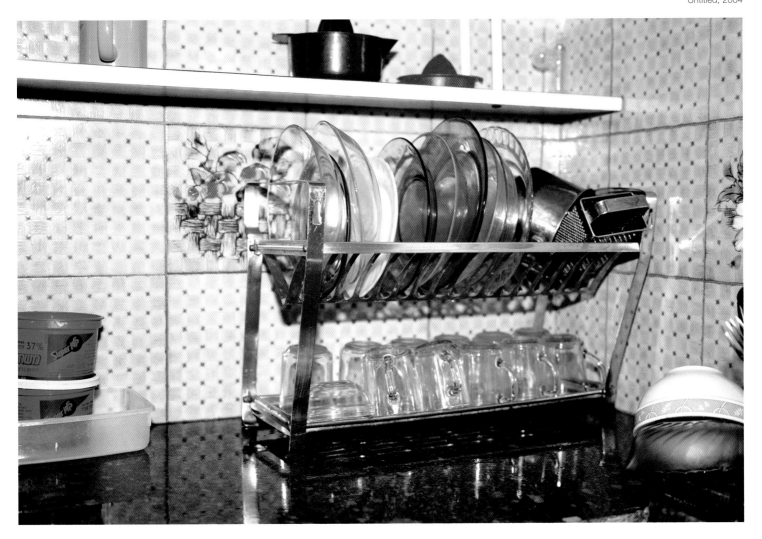

Untitled, 2004

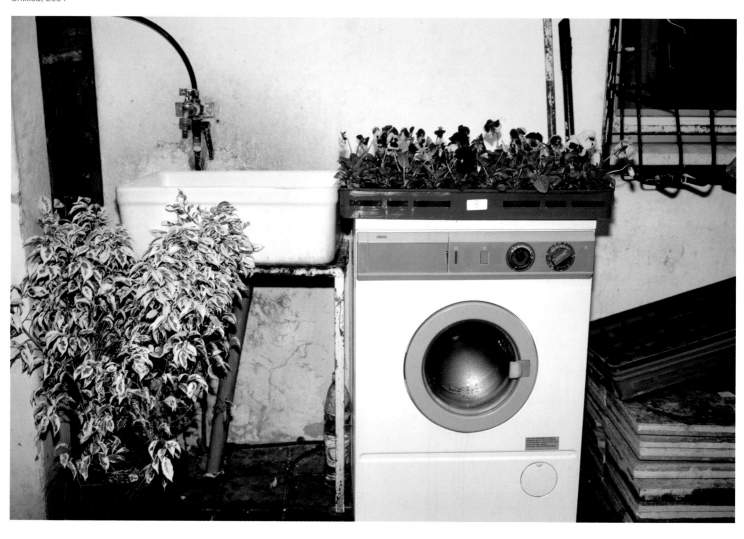

RYO OHWADA

Japan, b. 1978
Tokyo Polytechnic University, Japan, 2002–2004

Ryo Ohwada creates strange landscapes using
a technique called 'neograms', which he developed
himself, although it was inspired by the early
experiments of the pioneers of photography.
Combining analogue and digital photography, and
colour and black-and-white images, Ryo Ohwada
creates kaleidoscopic landscapes through a long
process of transformation. He attempts to depict
an imaginary, utopian space, created in his mind
and reflecting the concentric structure of the world,
like that represented by mandalas. In giving form to
his mental images, Ryo Ohwada explores his own
connection with the spiritual world.

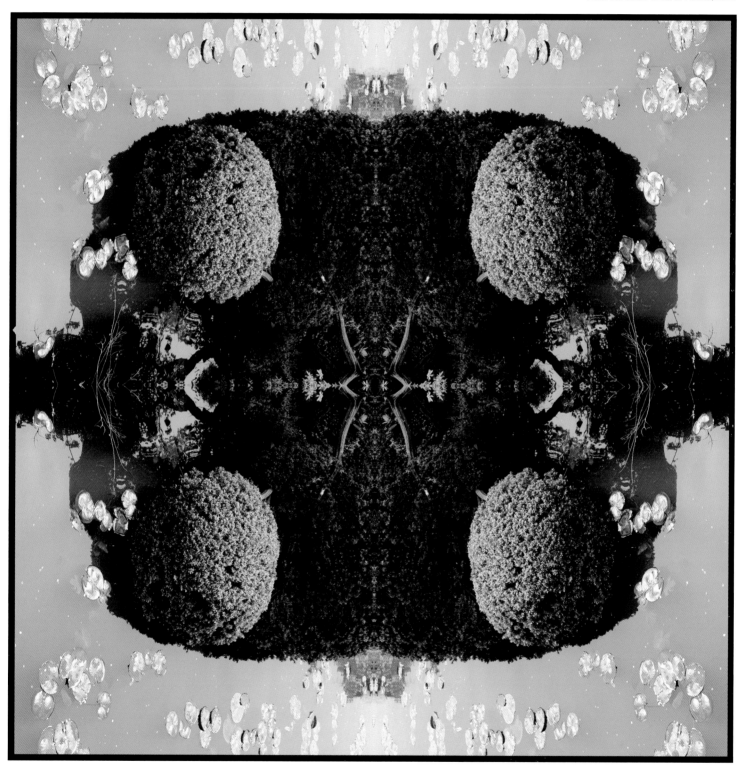

From the series *World of Round*, 2004

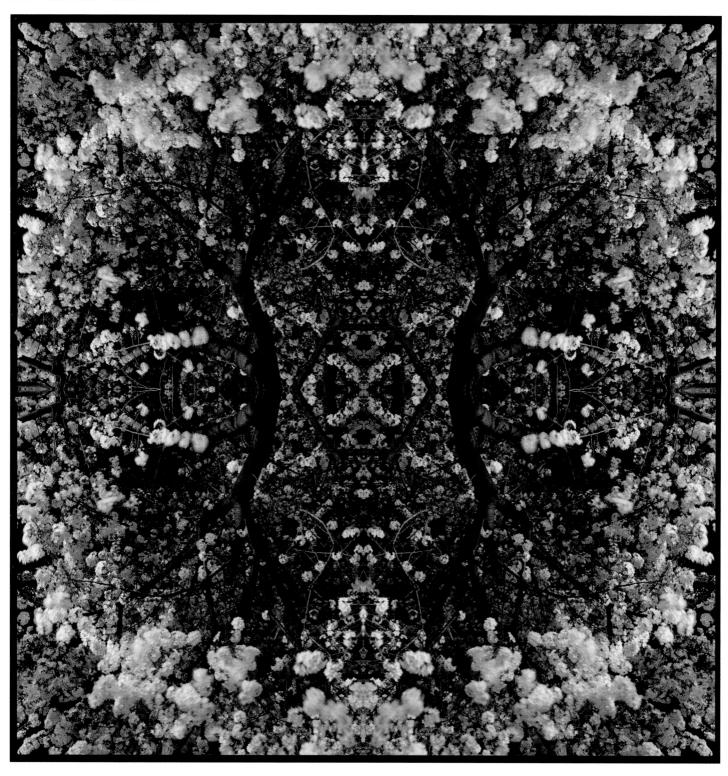

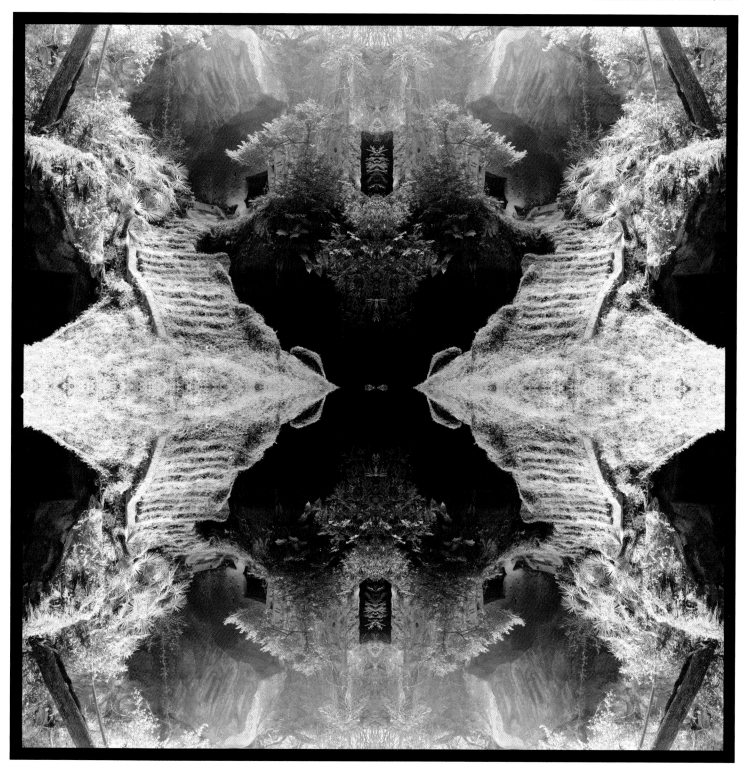

SUELLEN PARKER

United States, b. 1972
School of Visual Arts, United States, 2001–2004
University of Georgia, United States, 1991–1996

Sculpture, photography, digital manipulation: Suellen Parker uses a combination of techniques to explore the fragile frontier that divides reality from illusion. The world she depicts is based around characters that she has modelled out of plasteline clay that never dries, allowing their features and forms to be endlessly modified. Parker photographs her sculptures and then reworks the images on a computer, making particular use of colours taken from the palette found in children's books. Starting from the fact that the books we read as children were those that first triggered our imaginations, she creates a body of work that has a similar effect on the viewer. The figures that she creates – like characters from a children's book – come to life in the viewer's imagination. The scenes shown in each photograph encourage us to invent a story. We see the characters trying, like real human beings, to make their bodies look perfect and desirable. They fight against the contradictions that exist between their ideal and their physical reality, and it is within this struggle that they find their humanity. In this series, Suellen Parker also wants to remind us that because as human beings we believe in illusions, we end up having to live with them.

Great Expectations, 2004

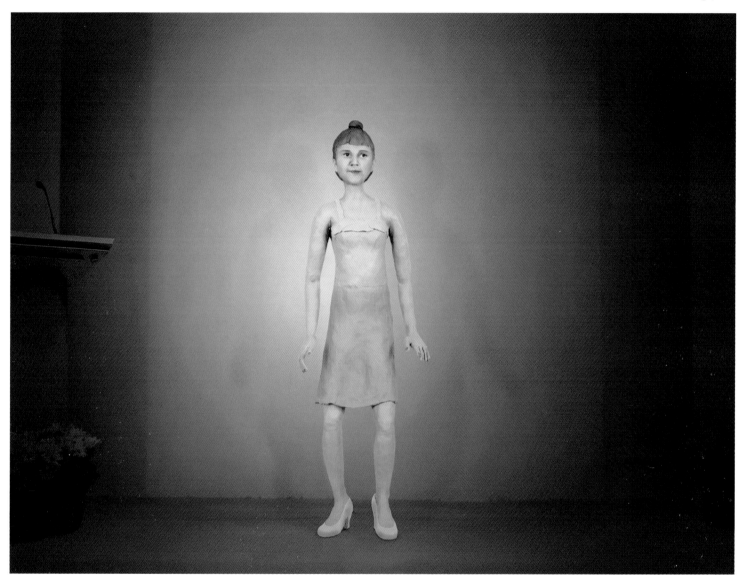

Glamour Shot, 2004

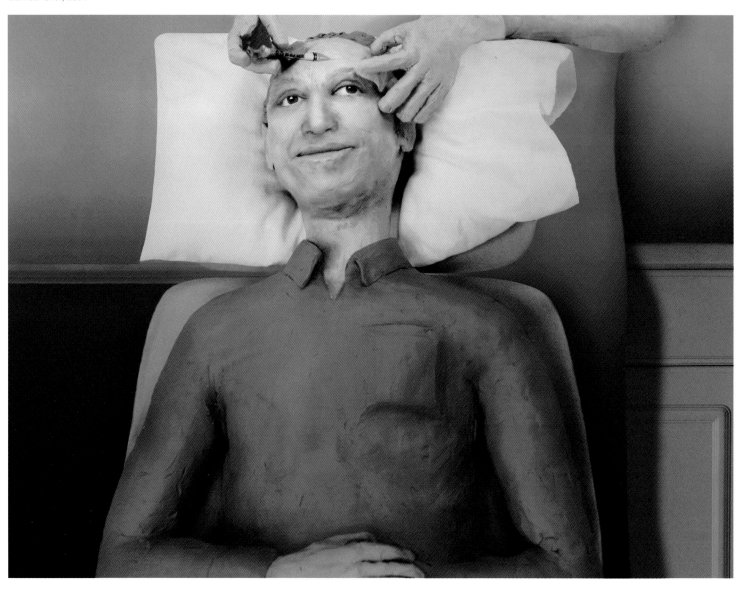

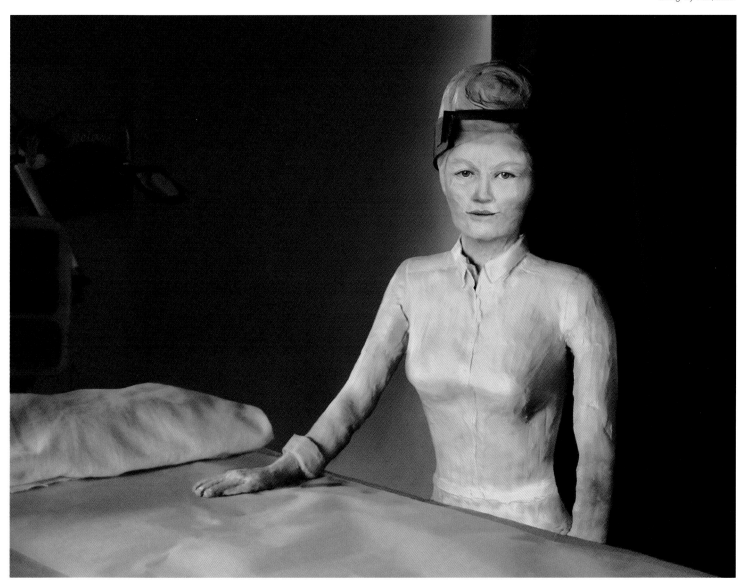

TED PARTIN

United States, b. 1977
Yale University School of Art, United States,
2002–2004
Fordham University Lincoln Center, United States,
1996–2000

Ted Partin starts from the classic tradition of black-
and-white photography and explores the medium
of the portrait. He concentrates on members of what
he calls the 'MTV generation' – young people who
are now overexposed by the medium of the image.
He plays with the idea of a so-called masculine,
feminine and gay gaze, a recurrent theme in
contemporary photography, and establishes direct
visual contact with his subjects, be they close friends
or strangers, to explore the interaction and the
interplay of appearance that occurs between
the model, the photographer and the spectator.

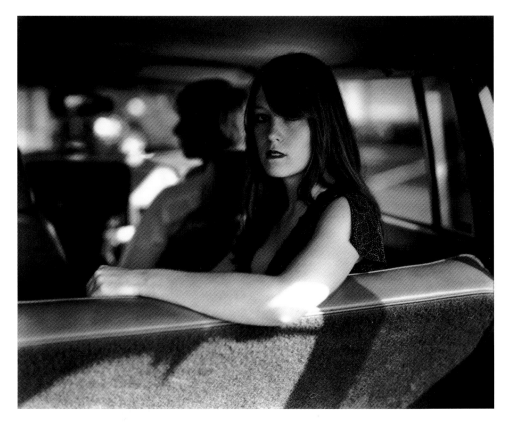

Mobile, 2003

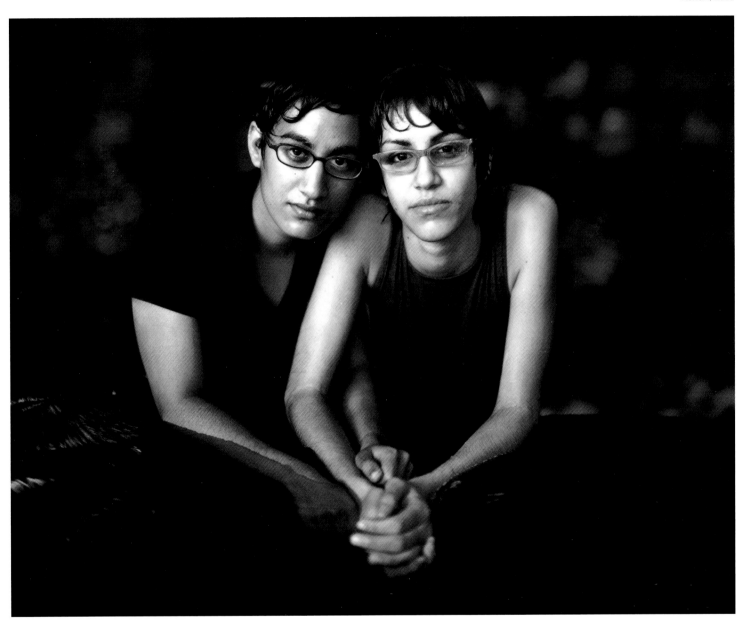

Norfolk, 2003

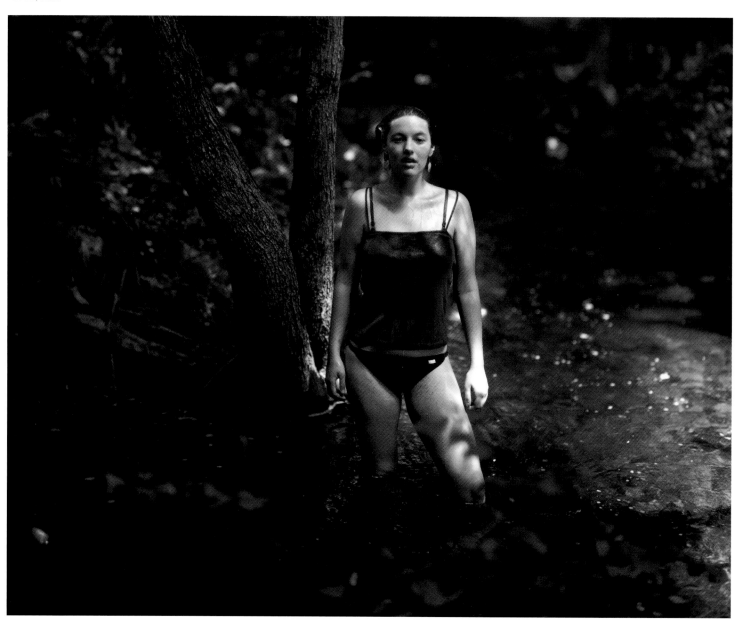

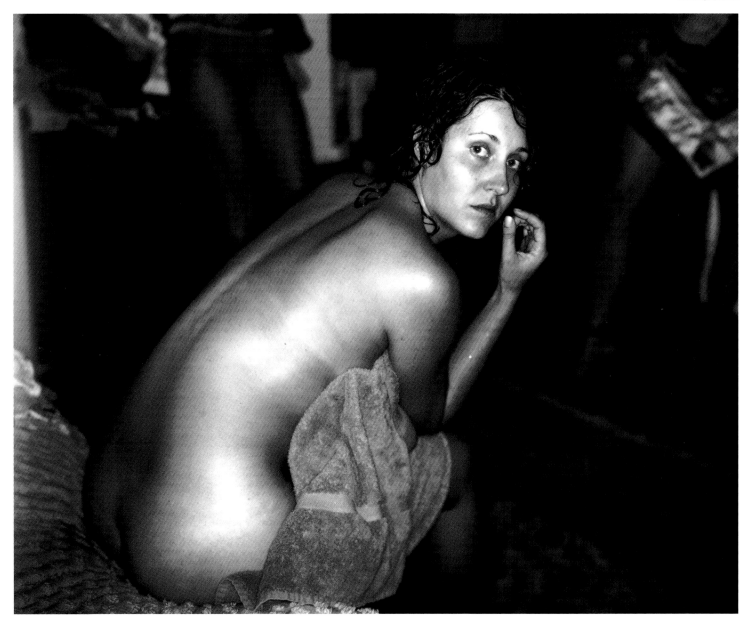

CHARLOTTE PLAYER

England, b. 1982

Nottingham Trent University, England, 2001–2004

Wimbledon Art School, England, 2000–2001

Richmond upon Thames College, England, 1998–2000

Charlotte Player works in countries that have been affected by war. She wants to bring back from her travels images that are different from those found in the media, in which war is reduced to violent clashes and displays of hatred. After several reports from Palestine, where she looked at families living with war on a daily basis, she travelled to Sarajevo. Player, then aged twenty-two, approached young people of her own age to talk about the war. As with her earlier work, she asked her subjects questions in order to get to know them better. She learned that most of the people she talked to were too young to be involved in the fighting. Many of them had spent four years hiding out in their cellars. Some of them had seen their friends return wounded from the fighting; others, slightly older, had had to go out and fight themselves. The war in Bosnia is now over. Despite the deep scars that remain from this period, Charlotte Player wanted to show that these young people, like anyone else of their age, liked to go out and party, and dreamed of a carefree life.

Mike. From the series *Sarajevo*, 2004

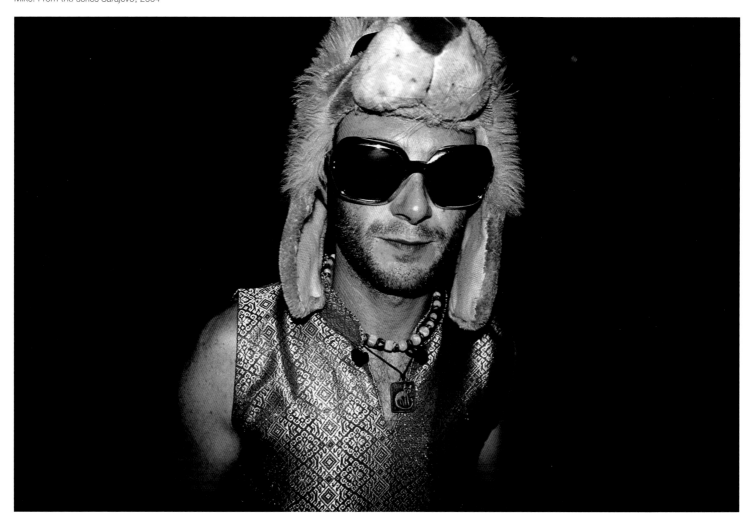

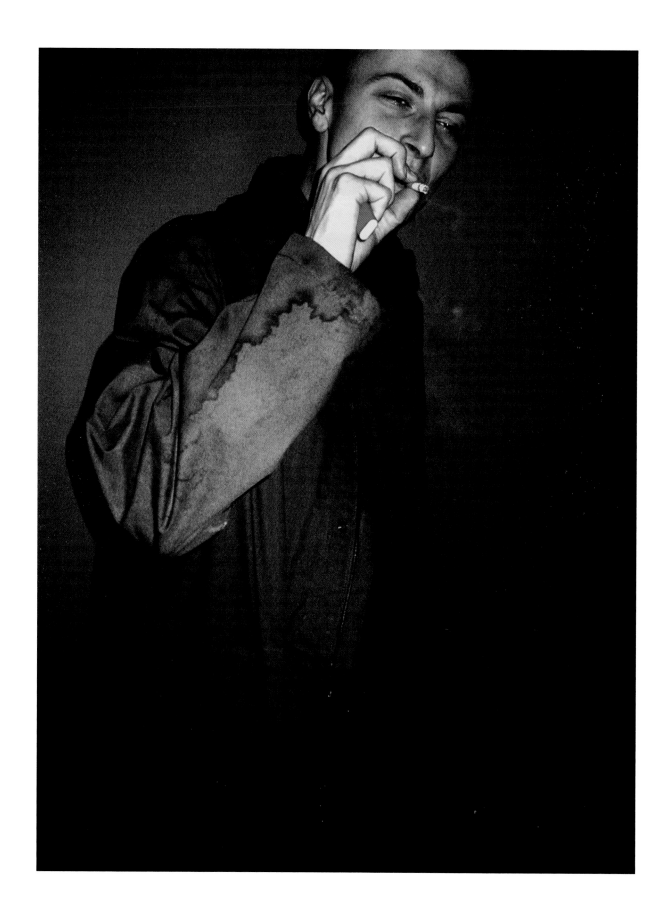

Jump. From the series *Sarajevo*, 2004

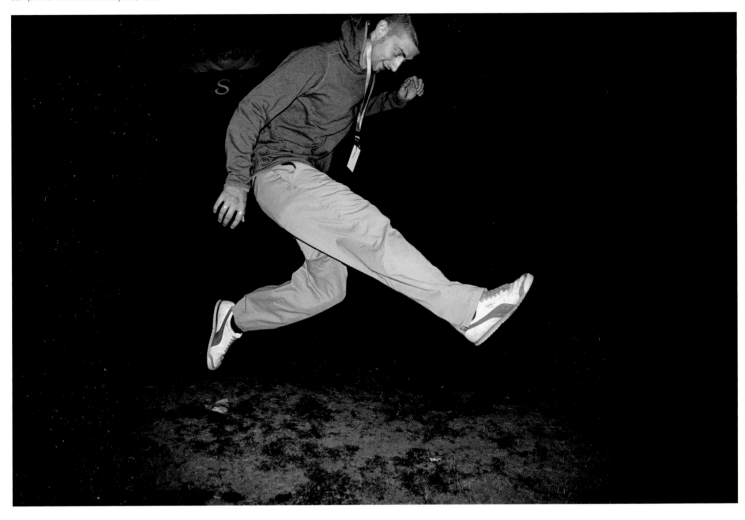

Bullet Holes. From the series *Sarajevo*, 2004

NICHOLAS PRIOR

United States, b. 1966
School of Visual Arts, United States, 2002–2004
Pennsylvania State University, United States,
1986–1991

Nicholas Prior is interested in two particular groups
of people: children and the homeless in contemporary
America. In their own ways, both of them live on the
margins of society, in a world that remains invisible
to many adults. In the series *Age of Man*, the
photographer looked at childhood as a social
construct rather than a biological distinction.
Deliberately leaving adults out of the picture field,
Prior showed children isolated in deceptively pleasant
surroundings. Although adults are physically absent
from the images, their world is imposed on the
children through their fashions, their conventions,
their technology and their rituals. In all of his work,
Prior subtly creates a somewhat unsettling world that
brings to mind a fairytale, a story in which fear and
reassurance are closely connected.

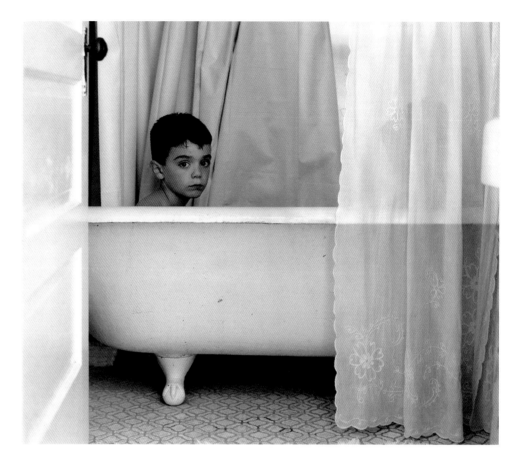

Untitled. From the series *Age of Man*, 2004

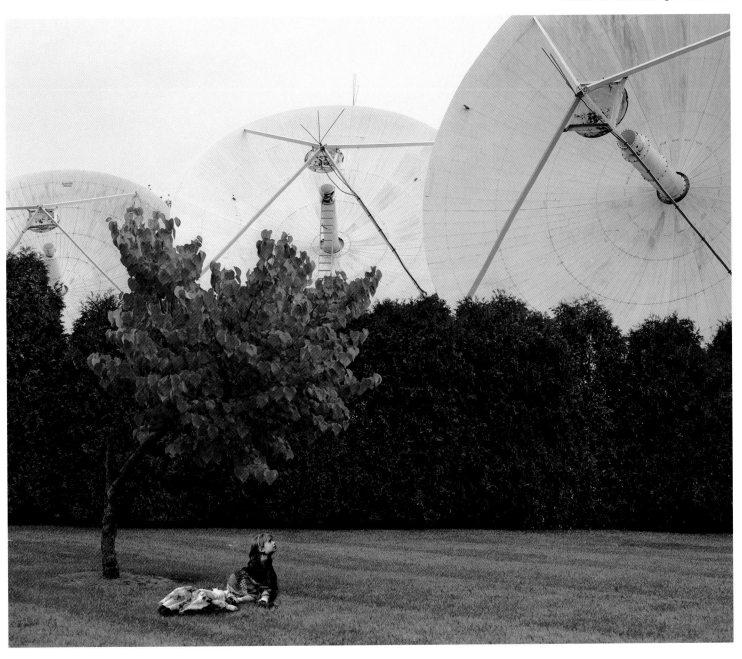

Untitled. From the series *Age of Man*, 2004

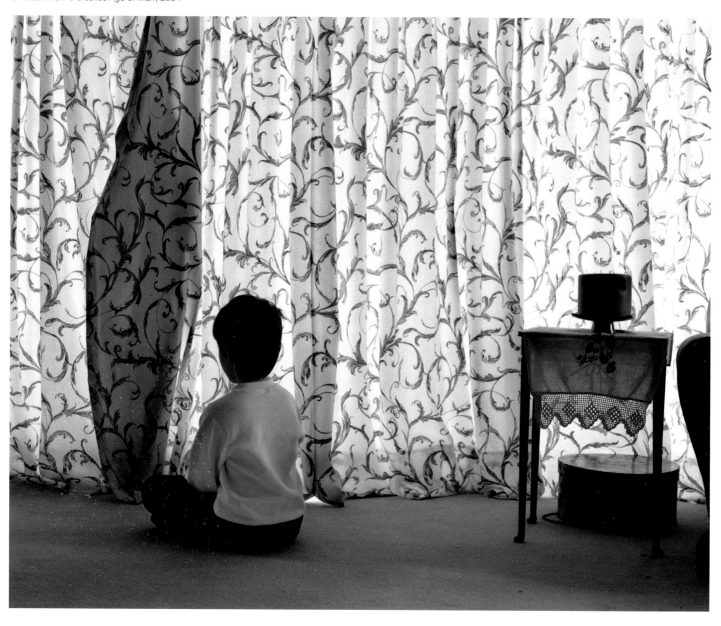

Otis, in the Compass Center, a transitional house in North Seattle. From the series *Home*, 2004

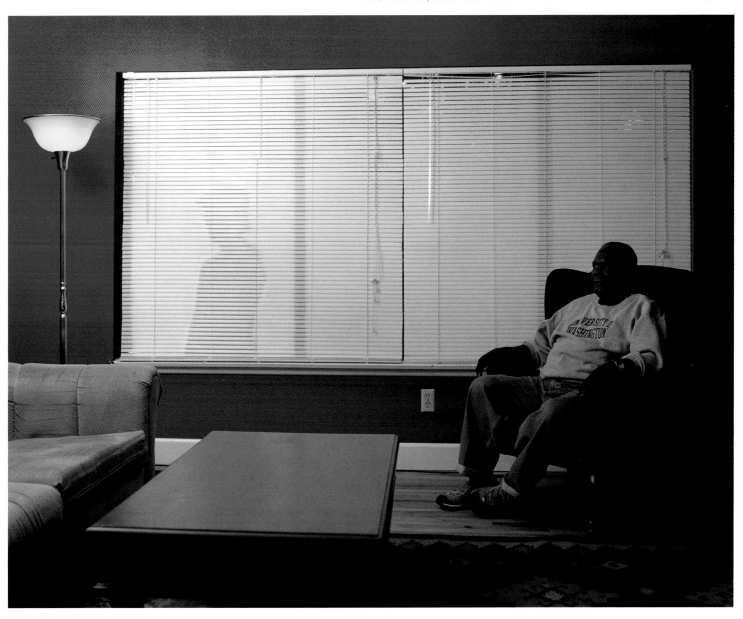

VALÉRIE ROUYER

France, b. 1972
Ecole Nationale Supérieure de la Photographie,
France, 1999–2002
Ecole Nationale des Beaux-Arts de Nîmes, France,
1998–1999

Valérie Rouyer has spent several years observing
the human body and its metamorphoses. Tracing
the ways in which the body may be completely
transformed – for either medical or cosmetic reasons
– has become a means for the photographer to
consider wider issues about the very essence of
being. Rouyer began this work in 2001 with the
series *Nature Morte* [Still Life], which went inside the
intimate world of the operating theatre. The sight of
the inside of the body often makes the viewer feel
deeply disturbed, a feeling that is reinforced here by
the presence of surgical instruments and the fact
that some of the body is hidden by a sterile sheet.
By using bright lighting, the photographer focuses
the viewer's attention on the body that is being
operated on, intensifying the violence of the scene.
However, the treatment of the image, particularly
the close framing and the use of black and white,
creates a psychological distance. The human body
is transformed into a sculpture, whose flesh can be
modelled in any way.

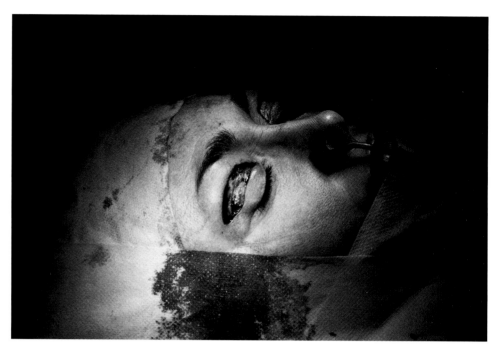

From the series *Still Life*, 2001–2002

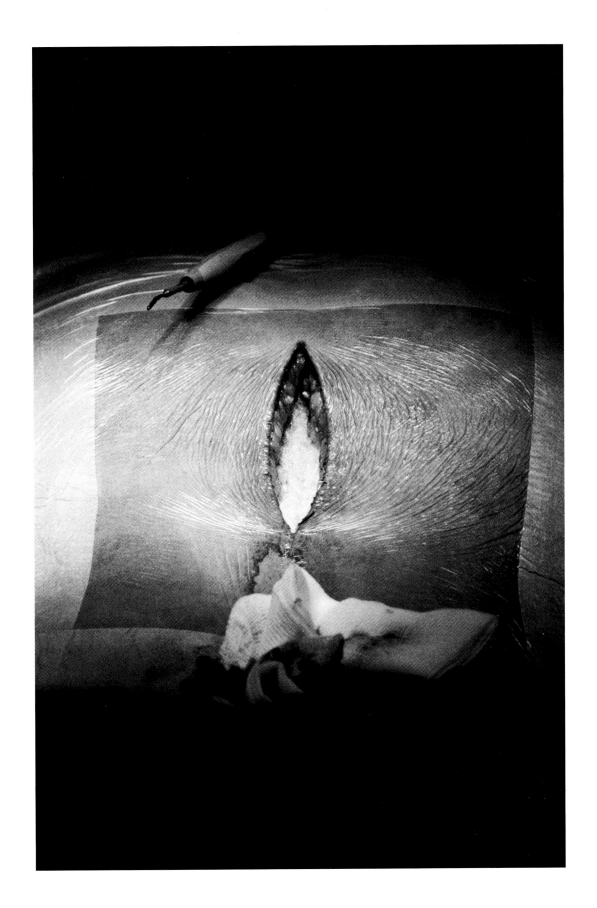

From the series *Still Life*, 2001–2002

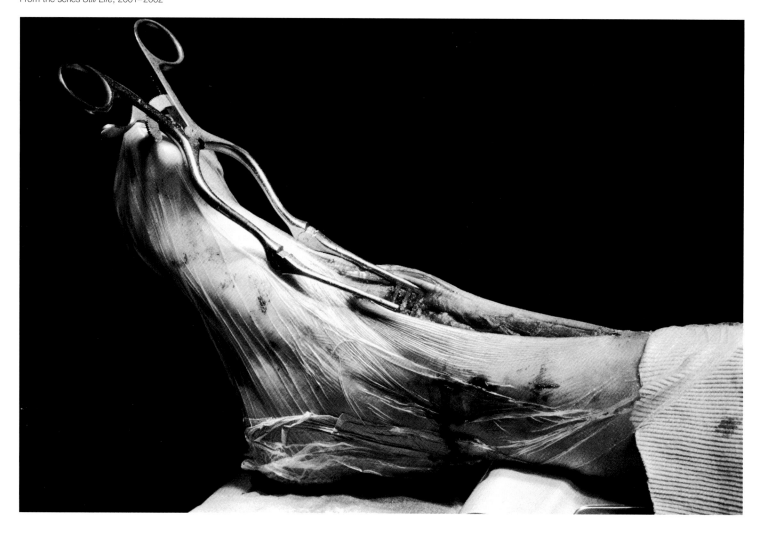

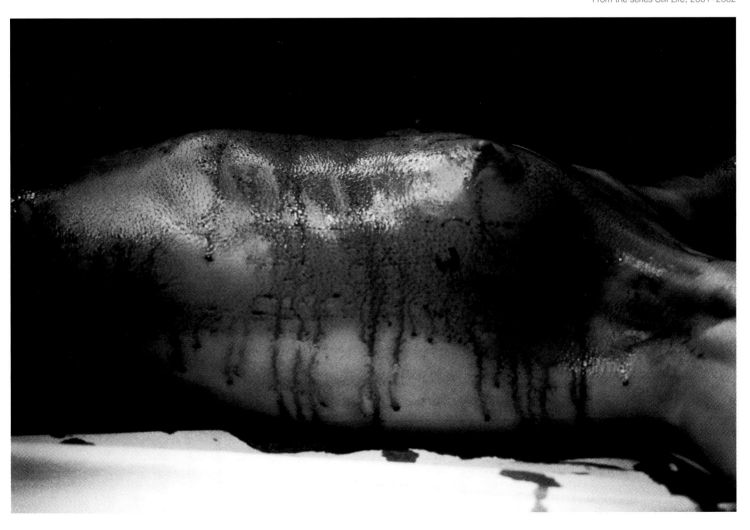

MARLA RUTHERFORD

United States, b. 1978
Art Center College of Design, United States,
2001–2004
Boston University, United States, 1996–2000

Marla Rutherford's photographs show a surreal
universe that brings together groups of people from
completely different worlds. The originality of her work
resides in the juxtaposition of images of children or
the elderly with portraits of people from the worlds
of sadomasochism and fetishism. By making the
latter group pose in ordinary surroundings, the
photographer brings the strange and the banal
together, and so allows viewers to feel more at ease
when faced with people whose practices are seen
as deviant. In her collection of brightly coloured
images, Rutherford uses a style close to advertising
photography, which is intended to seduce the viewer.
Portraits of people from a community that is part of
the counterculture of America are brought out into
the light of day and treated as a subject as
commonplace as a smiling baby or an old lady
sitting in her living room.

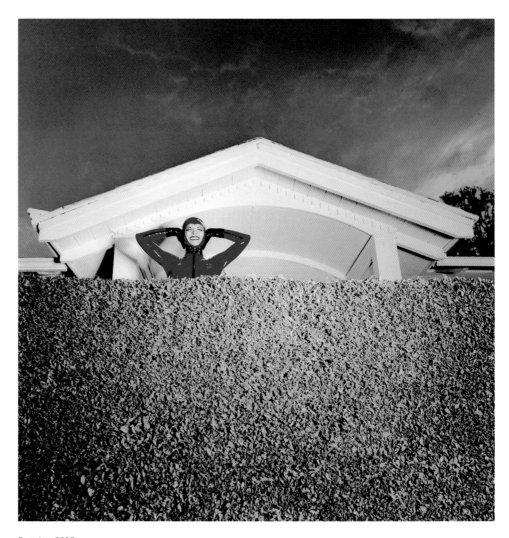

Surprise, 2005

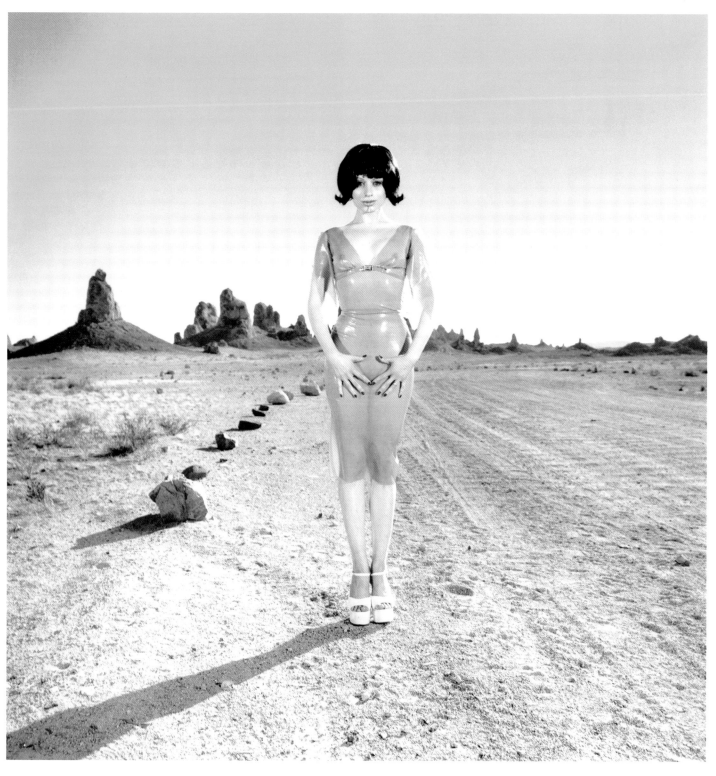

Fetish Coffee and Grandma, 2005

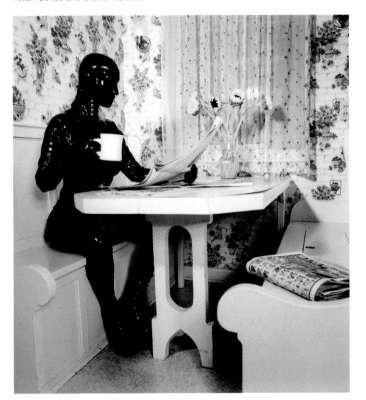

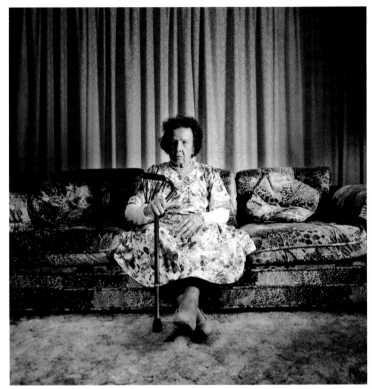

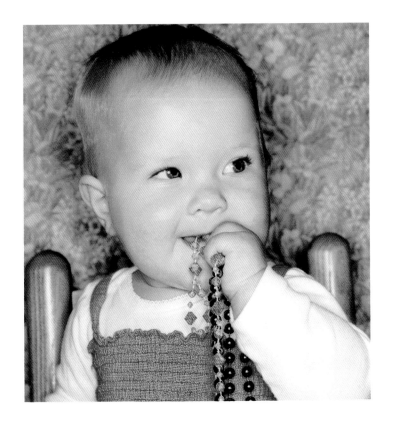

JOHANN RYNO DE WET

South Africa, b. 1982
Tshwane University of Technology, South Africa,
2001–2004

Johann Ryno de Wet combines the capabilities
of analogue photography and digital technology
to create landscapes that are not as he sees them
but as he feels them. By combining different
techniques – altering exposure time, darkroom
manipulation, computer retouching – he explores
a kind of landscape photography that is divorced
from conventional perceptions of reality. In so doing,
he reminds us that most landscapes from the history
of painting showed only what the artists wanted to
show or saw in their imaginations. Using this as a
departure point, he manipulates his photographs in
different ways in order to share with the viewer the
images that were created in his own mind after
seeing a striking landscape. Classical photography
becomes a basis for the reproduction of his own
mental images, which are given their final form by
digital means.

Giant's Castle, 2004

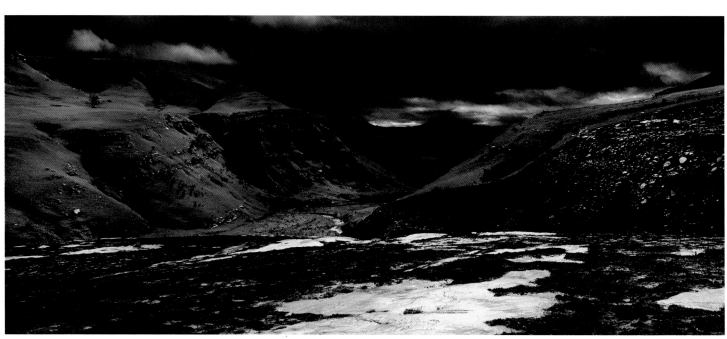

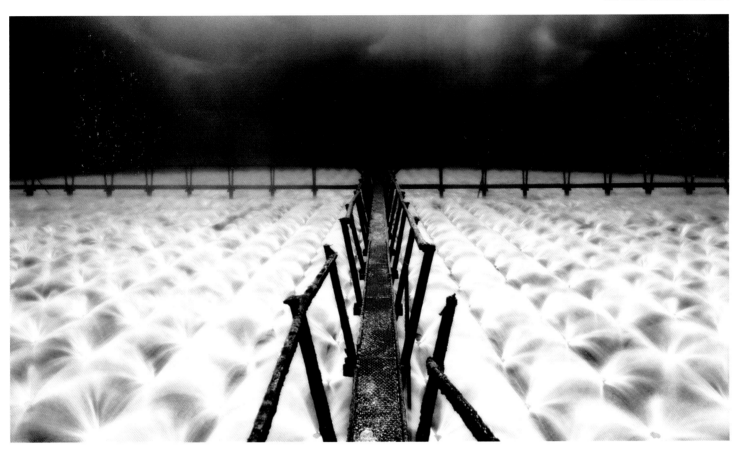

Brick Factory, 2004

MARTINA SAUTER

Germany, b. 1974
Kunstakademie Düsseldorf, Germany, since 1999

Appropriation, misappropriation, continuation: these
are the registers in which Martina Sauter operates.
For several years, she has been exploring the
perception of images from films, which she displays
out of context. To do this, she appropriates them in
two different ways. In the first, she works with stills
from movies – particularly by Alfred Hitchcock –
which she reassembles into new images. Deliberately
allowing her collage technique to remain visible, she
puts together different parts of an image to create a
new space within it. Her second approach is to take
her camera to revisit places that have been used as
film locations. Her photographs taken in the Alte
Nationalgalerie in Berlin make direct reference to
places visited by the lead characters in Hitchcock's
Torn Curtain. Sauter re-photographed the locations
where the director filmed in 1966 – in fact, the original
locations were entirely rebuilt in a studio, because the
filmmakers could not obtain permission to film in the
real museum, which belonged to the GDR at the time.
Inspired by Hitchcock's work, Martina Sauter evokes
a similar atmosphere of mystery and suspense.

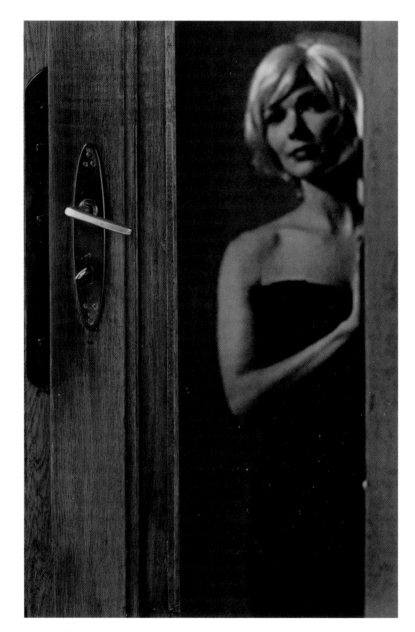

Twist 1, 2004

Treppe [Stairs], 2004

Durchblick I [View I]. From the series *Rooms*, 2004

Durchblick II [View II]. From the series *Rooms*, 2004

JOSEF SCHULZ

Germany, b. Poland 1966
Kunstakademie Düsseldorf, Germany, 1993–2002

Josef Schulz has only one subject: mass-produced prefabricated buildings. He makes no attempt to pay homage to this type of industrial architecture, which can be found anywhere in the world, nor does he criticize it. Instead, he uses it to build up a kind of lexicon. Schulz works in two stages: first he photographs industrial warehouses and factories, using a traditional photographic technique – a 4x5 camera, which has the main advantage of capturing precise detail because of the large format of the negatives. The image is then transferred to a digital format and computer-processed to 'clean up' any clues that could indicate a particular place, time or environment. This alters the physical reality of the building, turning it into a perfectly contoured object placed in an indeterminate location. Paying close attention to colours and shapes, Schulz reduces the buildings that he photographs to architectural sets. The real building becomes a concept, the original photographic image becomes a new virtual image. Using a procedure that distances him from the supposed objectivity of photography, Schulz shows that pictures are always constructions from the artist's imagination.

Form #7, 2003

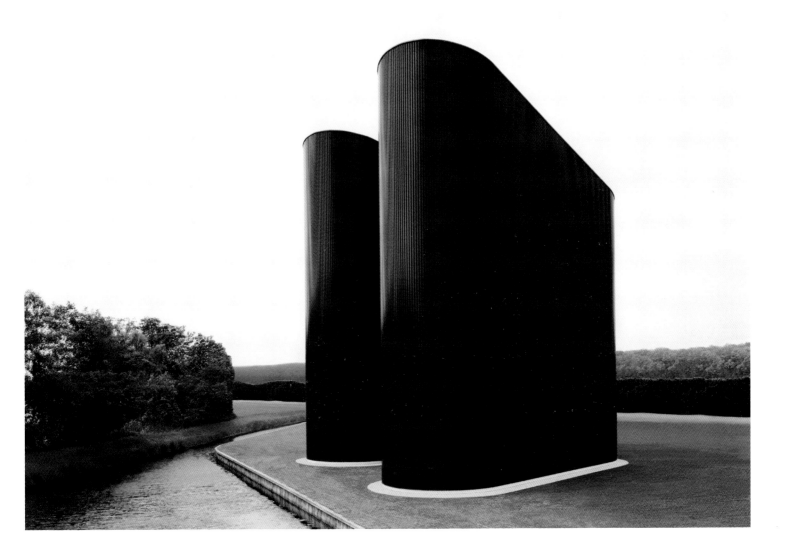

Brick, 2003

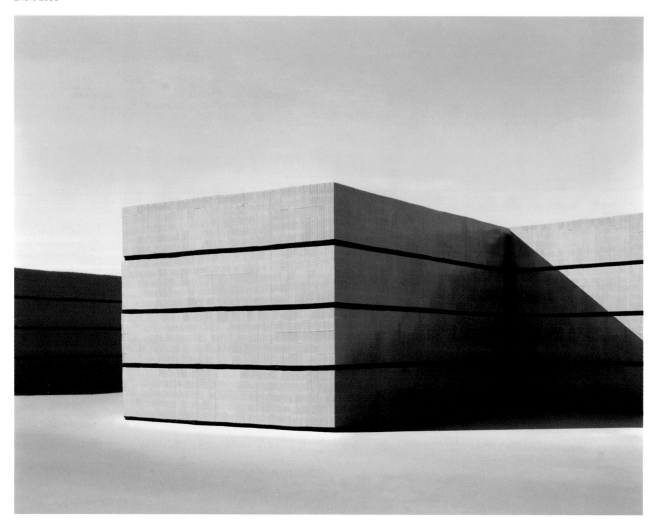

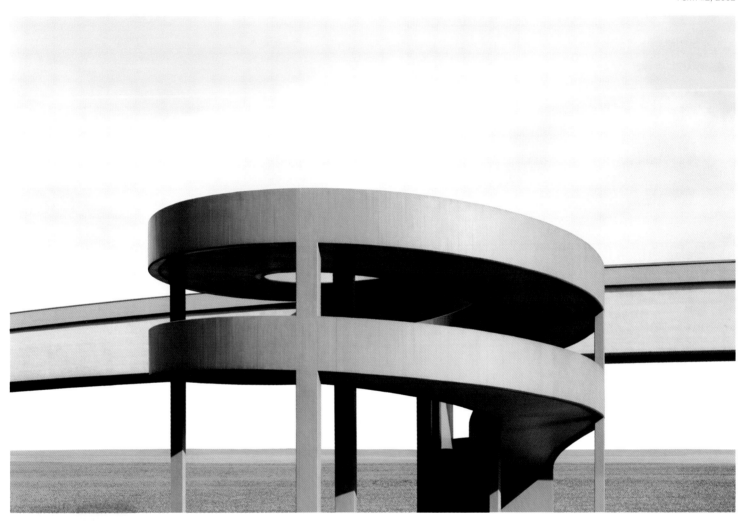

MONA SCHWEIZER

Switzerland, b. 1978
Ecole d'arts appliqués Vevey, Switzerland,
1999–2004

The series *zone ###*, whose title refers to the
expression 'zone secured', depicts the interior of
buildings that are entirely fenced off and placed under
high-security surveillance, such as dams or nuclear
power stations. It also consists of portraits of the
workers who are shut into these workplaces.
Mona Schweizer wanted to get inside man-made
closed environments – true fortresses, protected
from the outside world – in order to gain a better
understanding of their power to control and alienate
individuals, who find themselves deprived of physical
reference points and human contact. The workers are
shown in such a way that they appear to be locked
inside their surroundings, and by extension, inside
their jobs. Schweizer lures us inside these fascinating
artificial environments and makes viewers feel
uncomfortable when they project themselves into
the isolation of the spaces she has photographed
and the world of repression that they represent.

Patricia Schulz, Director of the Federal Office for the Equality of Women and Men.
From the series *zone ###*, 2004

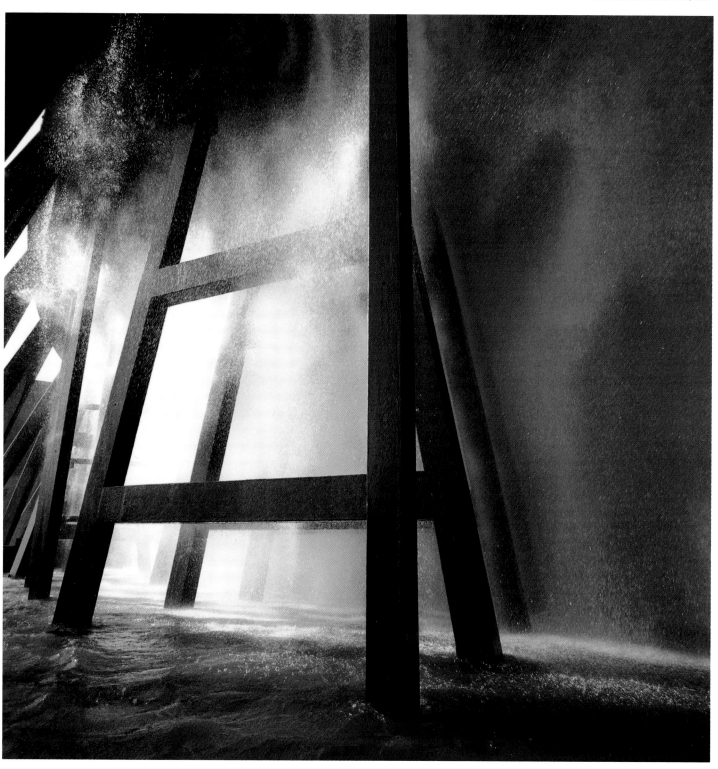

From the series *zone ###*, 2004

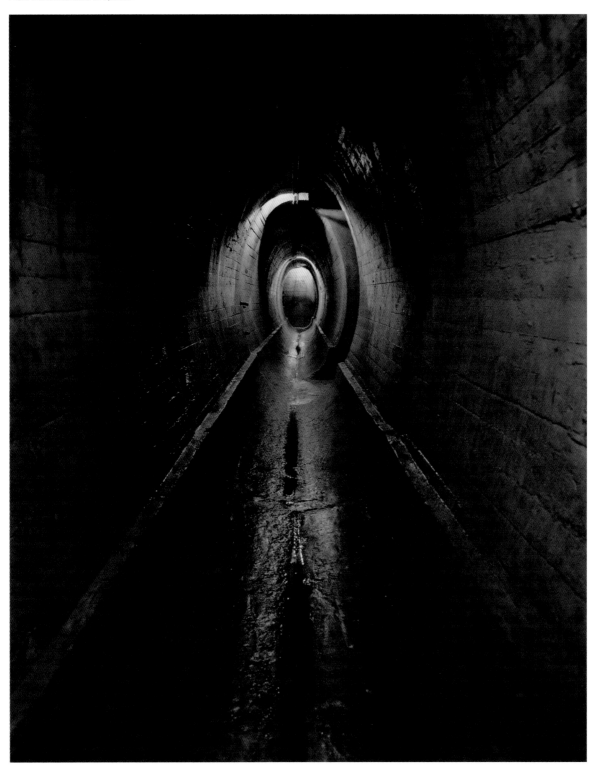

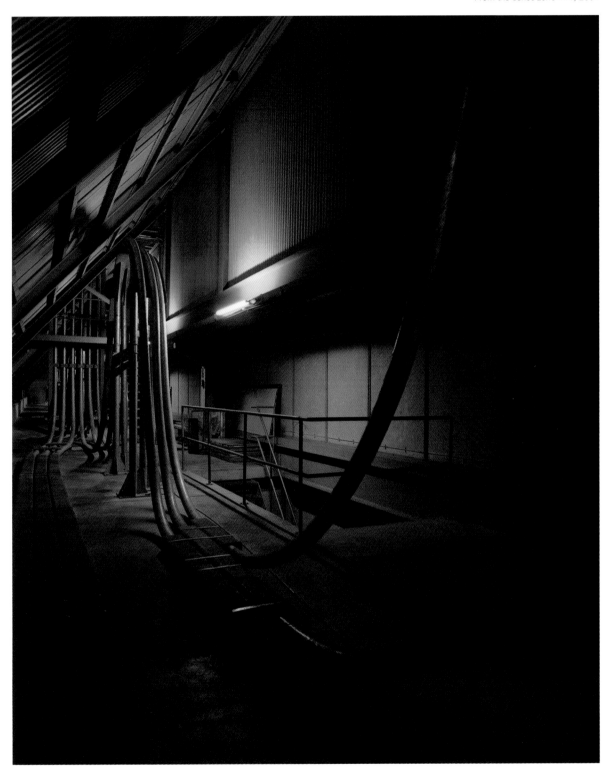

CAROLINE SHEPARD

United States, b. 1969
School of Visual Arts, United States, 2000–2002
Sarah Lawrence College, United States, 1987–1991

With a body of photographic work that links ancient methods of image-making with the latest digital technology, Caroline Shepard takes a new approach to the genre of portraiture, with particular reference to the world of Dutch paintings of the 17th century. Her work since 2001 shares several features with the work of those painters: she uses the screen of her computer as a canvas, a support on which she creates the entire image, building up the light and shade as painters do to give coherence to the portrait. Her images are made up of several different photographs taken in the same place but each one showing a different subject. All of these shots are then digitally merged into a single image. As in a painting, Shepard works layer by layer, touching in the colours, drawing the perspective. This technique, which slows down the image production process enormously, was developed by the photographer to allow her to build up a more intimate relationship with her subjects and create richer representations of her contemporaries.

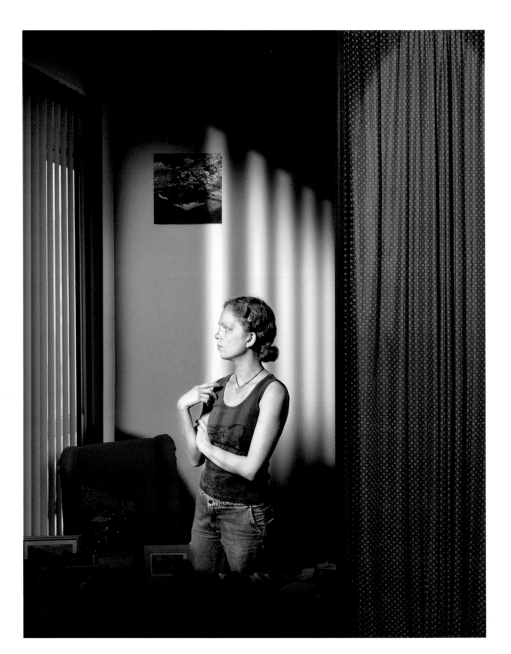

Gerana, 2002

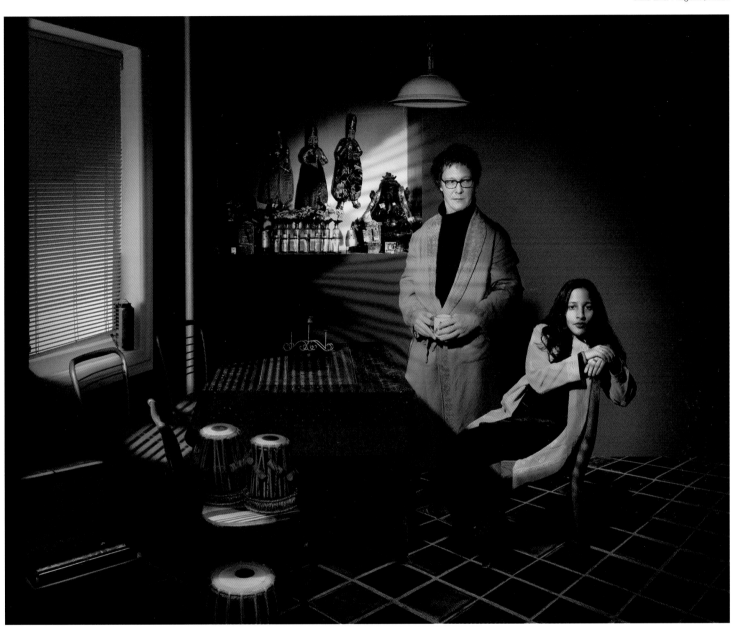

Benjamin, 2001

ANGELA STRASSHEIM

United States, b. 1969
Yale University School of Art, United States,
2001–2003
Forensic Imaging Bureau, Florida, United States,
1997
Minneapolis College of Art and Design,
United States, 1995

Angela Strassheim has developed her own original
style by photographing carefully composed and
mysterious scenes. Inspired by her own childhood
(she was born into a family of fundamentalist born-
again Christians) and her experiences as an adult
(she trained as a medical and legal photographer),
she has built up a complex body of work in which
images of families, which seem at first to have an
air of calm and security, are juxtaposed with scenes
of domestic life that are suggestive of hidden
psychological traumas or violence. The series *Left
Behind* depicts an unsettling domestic world and
brings together themes such as religion, suburban
life and personal memories.

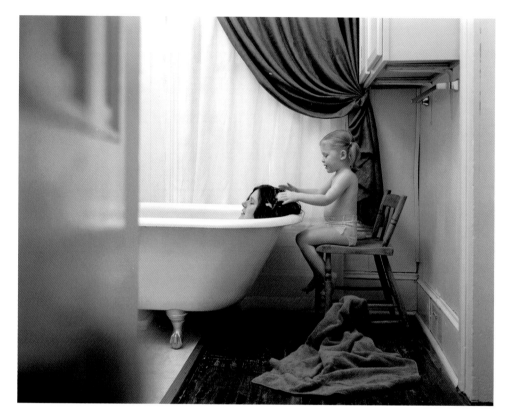

Untitled. From the series *Left Behind*, 2003

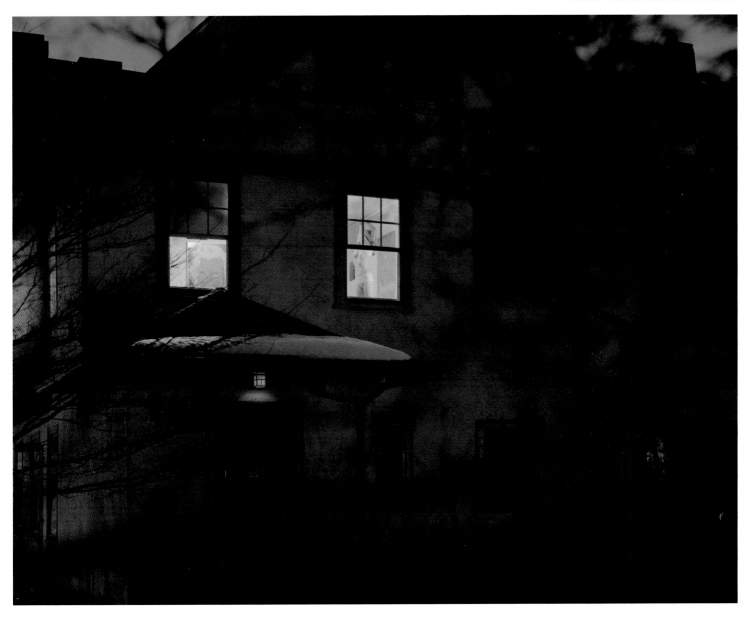

Untitled. From the series *Left Behind*, 2003

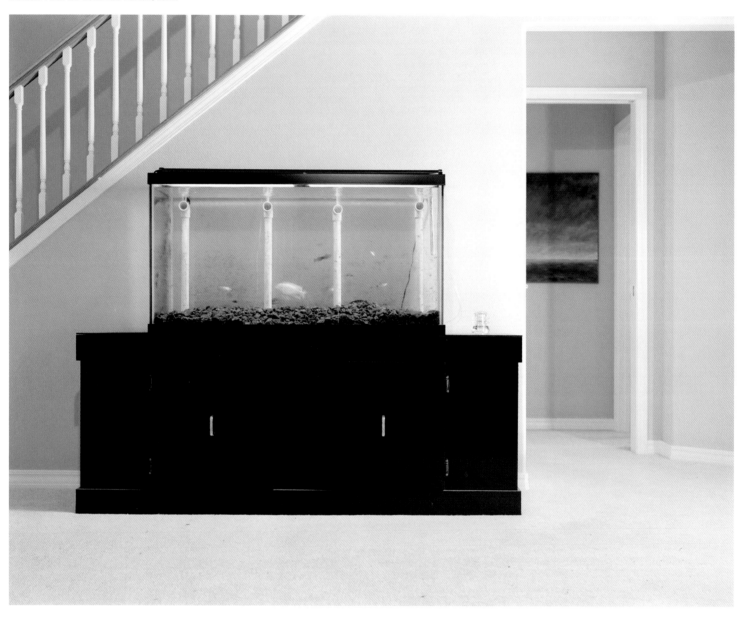

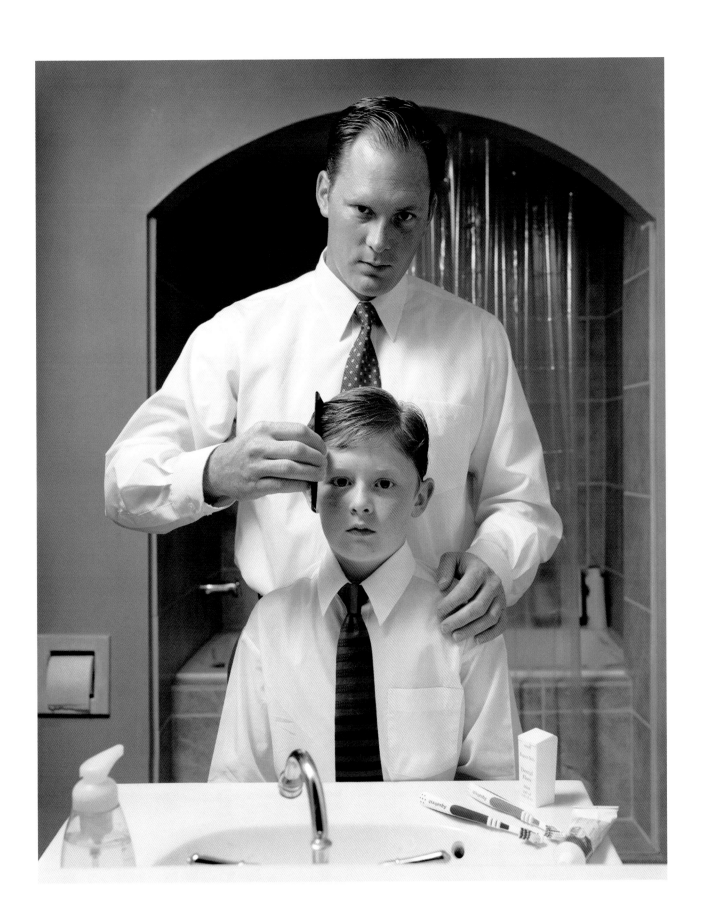

CATHRINE SUNDQVIST

Sweden, b. 1972
London College of Communication, England,
2001–2004

Cathrine Sundqvist uses the world of horseriding
as a pretext for examining the feminine condition.
Whether in her portraits of stable girls or her portraits
of horses, she creates scenes with her models that
explore images of womanhood. In the series *Miss
Wibora,* she reacts against the discipline forced upon
the female body, whose shape must be monitored
and controlled at every stage of life. This theme is
continued in her portraits of stable girls, who fix the
viewer with an assured and challenging gaze.
Sundqvist explains that a stable girl is not defined by
her sex. Seen as asexual, she earns her autonomy
not by fighting or winning medals, but through sweat
and tears. In the series *A Warriors Confession*, the
photographer makes direct reference to the figure of
Santa Lucia, who is celebrated in Sweden on one
of the longest nights of the winter. Like the saint,
the girls are blonde and dressed in white. However,
a black riding helmet replaces Lucia's crown of
lingonberry sprigs and candles, and a riding crop
takes the place of the traditional saffron buns.

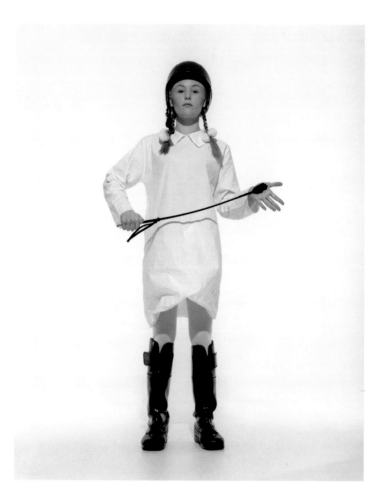

A Warriors Confession #2, 2003

A Warriors Confession #3, 2003

A Warriors Confession #5, 2003

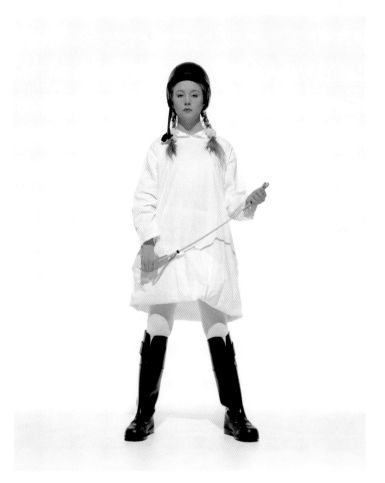

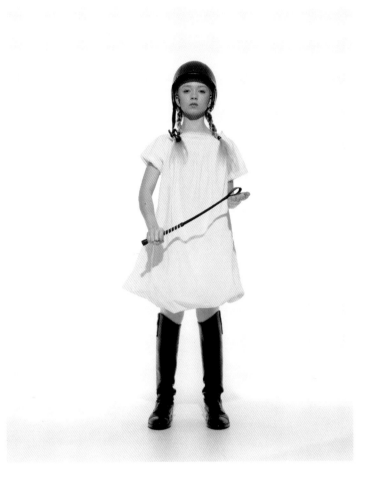

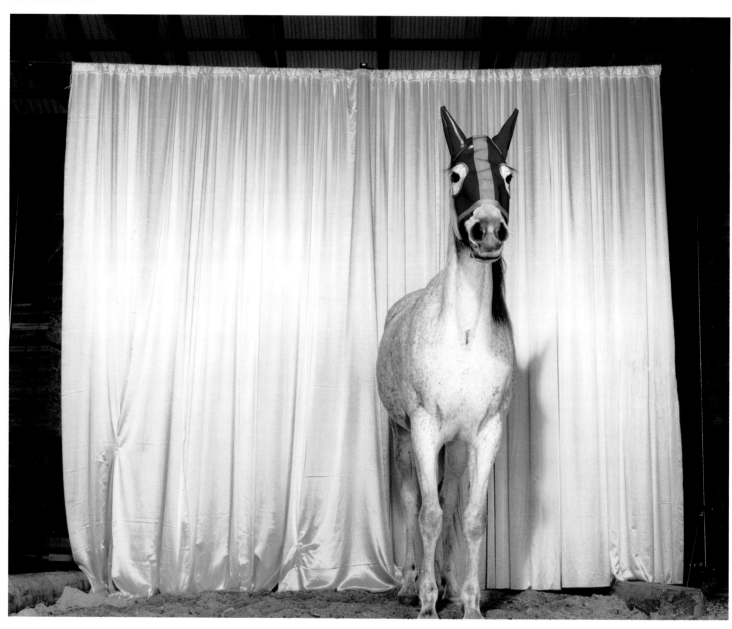

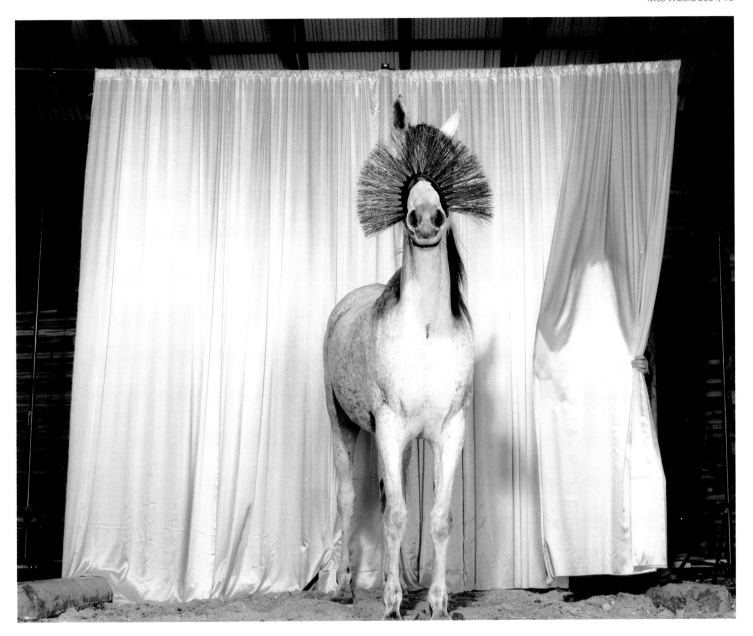

SHIGERU TAKATO

Japan, b. 1972
Elam School of Fine Arts, New Zealand, 2000–2003
Kunstakademie Düsseldorf, Germany, since 2003

The television studios photographed by Shigeru Takato in various cities of Europe and New Zealand blatantly display their artificial nature. They are lit as if for a broadcast, but imprisoned by their sets, and devoid of the human presence and sounds that usually bring them to life. The artist questions the power of television, whose studios are coming more and more to resemble spaceships in a science fiction film, and who in a few seconds can release their cargo of images, ideas and news onto the entire world. Contrary to what is generally believed, the true star is television itself and not its presenters, who are in fact quite ephemeral.

Cologne IV. From the series *Television Studios*, 2004

Zurich II. From the series *Television Studios*, 2004

Auckland III. From the series *Television Studios*, 2002

PÉTUR THOMSEN

Iceland, b. 1973
Ecole Nationale Supérieure de la Photographie,
France, 2001–2004
Ecole Supérieure des Métiers Artistiques Montpellier,
France, 1999–2001
Université Paul Valéry Montpellier III, France,
1998–1999

A photographer from Iceland, Pétur Thomsen
has chosen the genre of landscape to create
unconventional images of his homeland. Inspired
by the destruction of the Icelandic landscape
caused by the largest building project in the country's
history – a hydroelectric power station – Thomsen
photographs different project sites from a distance,
especially the construction of major dams. Taking
a highly controversial Icelandic news story as his
subject, he makes images in which all human
presence has been removed, in order to reflect
more widely on the world and its large-scale
transformation through forms of technology that
claim to be ever more efficient.

Imported Landscape, Sultartangi, Iceland, 2003

Imported Landscape, Kárahnjúkar, Iceland, 2004

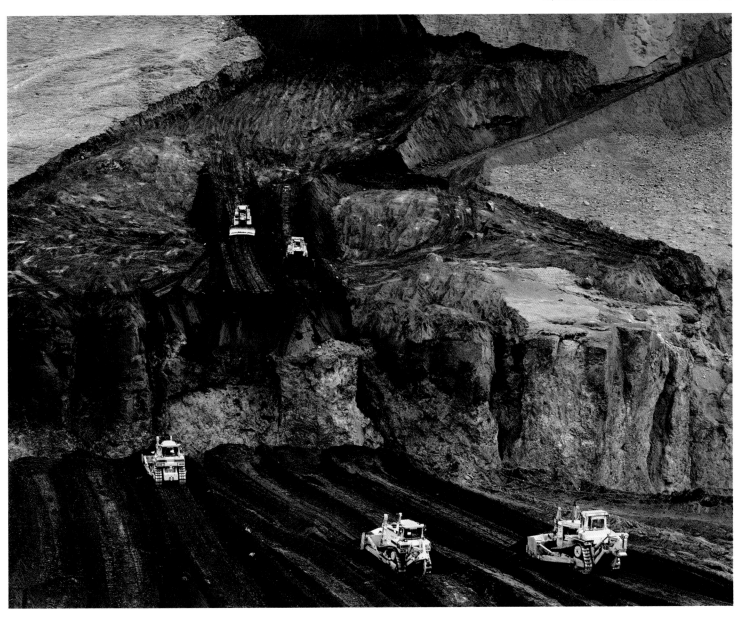

MIEKE VAN DE VOORT

Netherlands, b. 1972
Rijksakademie van Beeldende Kunsten Amsterdam,
Netherlands, 2004–2005
Koninklijke Academie van Beeldende Kunsten
Den Haag, Netherlands, 1994–1998
University of Witwatersrand Johannesburg,
South Africa, 1991–1993

With this series made between 2002 and 2004,
Mieke Van de Voort allows us into the private lives
of the recently deceased. Carried out in collaboration
with Amsterdam social services, the project shows
the interiors of apartments just as they were found
by social workers who were researching the identity
of people who had died without any known friends
or relations. Within the context of a wider examination
of the isolation and anonymity that affect city-dwellers,
Van de Voort tries to preserve both a physical and
spiritual trace of people forgotten by the world, who
died in complete solitude.

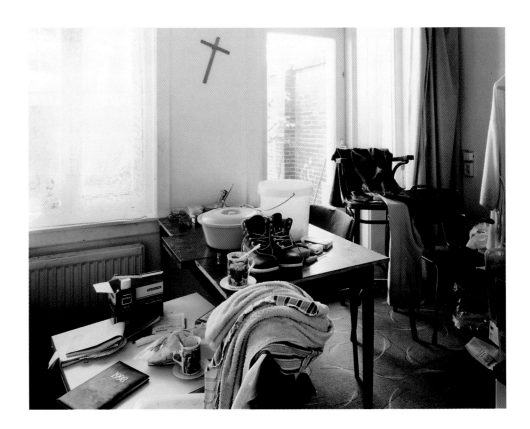

Rufus. From the series *People who died alone*, 2003

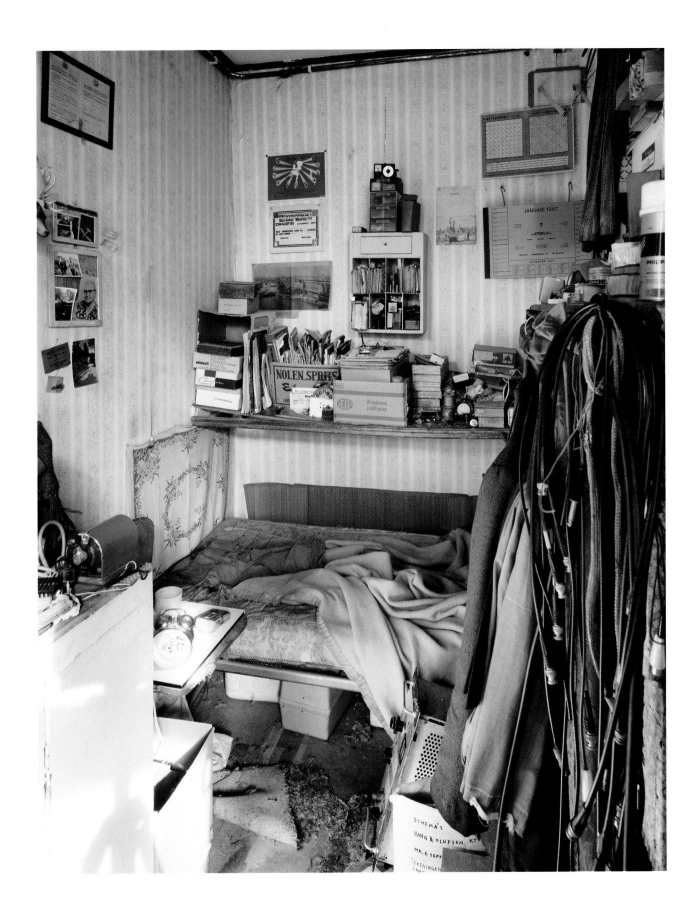

Cor. From the series *People who died alone*, 2002

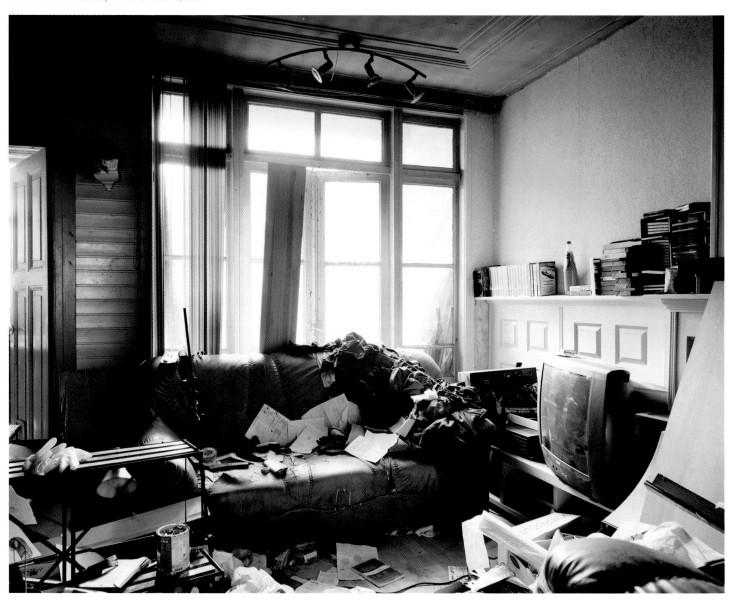

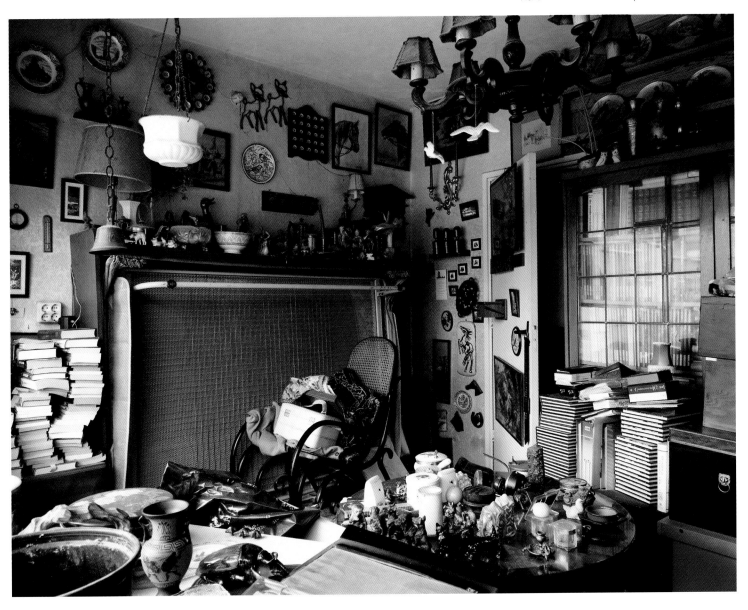

RAFFAEL WALDNER

Switzerland, b. 1972
Hochschule für Gestaltung und Kunst Zürich,
Switzerland, 1999–2002
Hochschule für Grafik und Buchkunst Leipzig,
Germany, 1995–1999

Fascinated by photography located at the crossroads of the artistic and documentary genres, Raffael Waldner aims to depict the ambiguity of everyday life. Whether in his series on industrial landscapes or his series on cars – both of which he worked on for several years – he observes everyday locations (public places, industrial sites) and everyday objects (cars) that have lost their original function. What becomes of a sports ground at night when no one is using it? What happens when a luxury car crashes and loses all its value? Waldner takes a fresh look at these specialized places and objects by observing them out of their usual context. Turned into large-format photographs on glossy paper, the shells of cars become icons of destruction, and empty urban locations become the relics of the industrialized world.

Hackney. From the series *Industrial Landscape*, 2002

Audi S6. From the series *Cars*, 2004

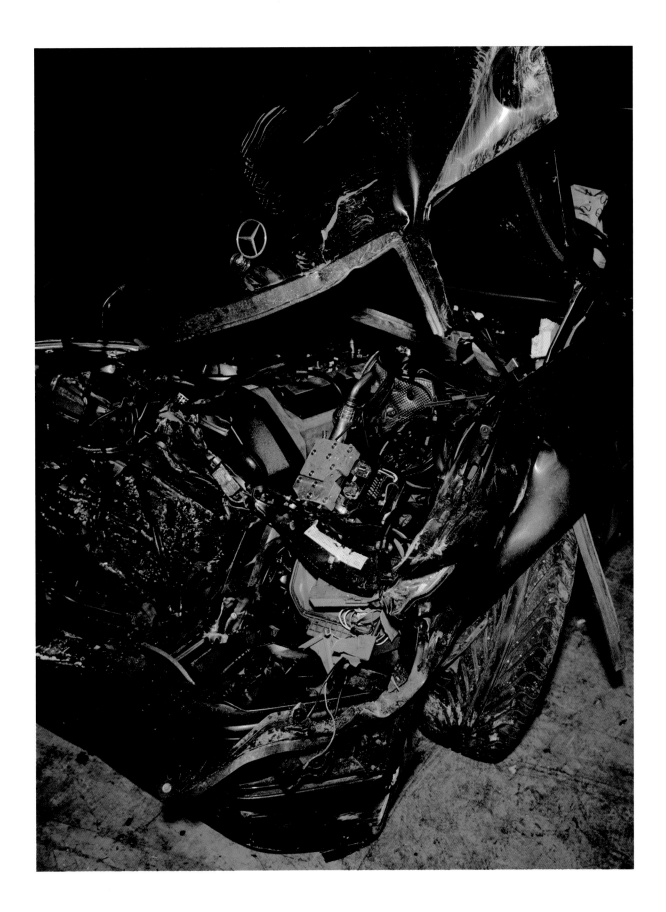

CHIH-CHIEN WANG

Taiwan, b. 1970
Concordia University, Canada, 2002–2005
Chinese Culture University, Taiwan, 1990–1994

Chih-Chien Wang has had first-hand experience of
immigration. Originally from Taiwan, he has chosen
to settle in Canada. The experience of being uprooted
is at the heart of his photographic world. He sees
any form of migration as a profound form of change,
affecting not only a person's identity but also
transforming their body. Using his own experience
as a starting point, he uses his camera to observe
his own body and the everyday objects around him
to see what becomes of them. To him, photography
is a means of showing that the human body and its
environment are intimately linked. Within this process
of mutation, Chih-Chien Wang shows that both bodies
and objects can be altered by desires, adjusted
according to needs, transformed by a gaze.

Orange Basket. From the series *Object*, 2003

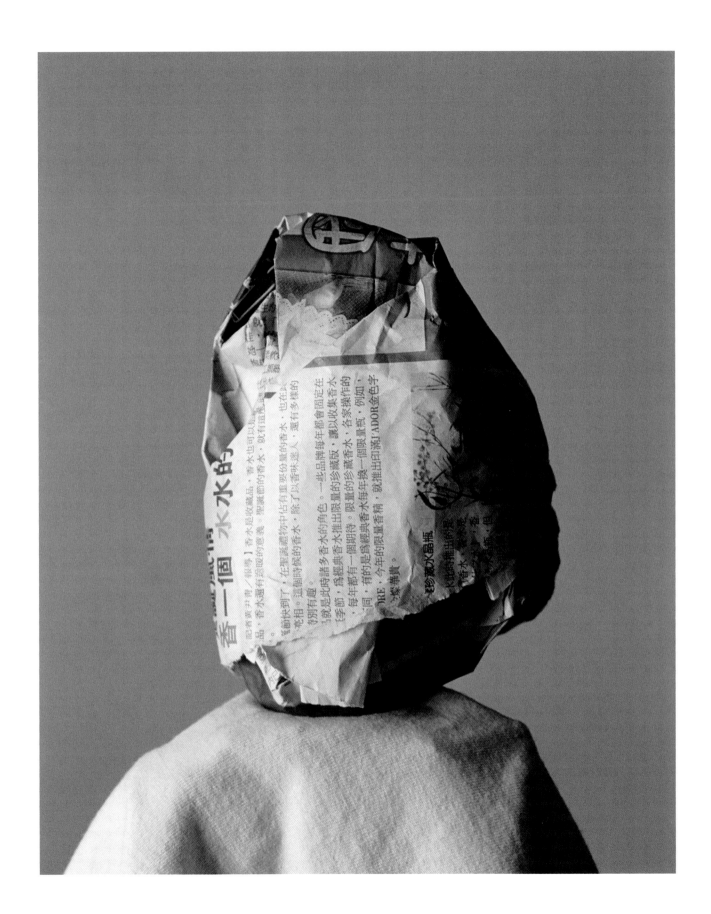

Red Man. From the series *Self-portrait*, 2004

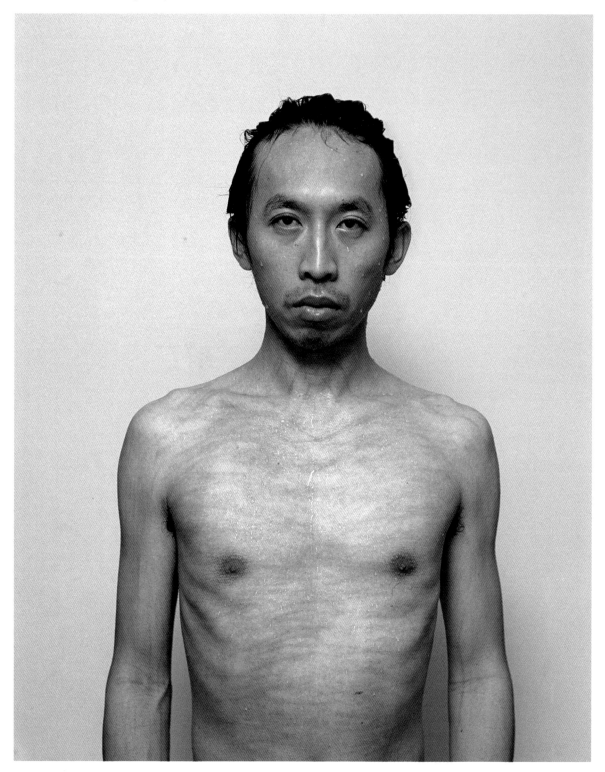

CARLIN WING

United States, b. 1980
Harvard University, United States, 1998–2002

What happens when an art photograph is hung on the wall of a company office? Does the surrounding space affect our perception of the exhibited work? Carlin Wing spent a year carrying out visual and anthropological research into the relationship between the world of art and the world of business. Using a 4x5 camera, a favoured tool of photographers who want to capture a lot of detail, she visited businesses that own works of art by artists as well known as Nan Goldin, Hiroshi Sugimoto or Thomas Ruff. Hanging on the walls of reception areas, meeting rooms or even in corridors, the exhibited works inevitably increase the so-called cultural value of the company image. Images of images and images of spaces, *Culture Inc.* shows what happens when a work of art – photographic, in this case – is placed within an environment other than that for which it is usually intended (the wall of a gallery or museum, the pages of a book) and reduced to a decorative element.

Thomas Ruff: Conference Room H. From the series *Culture Inc.*, 2002

Elger Esser: Conference Room K. From the series *Culture Inc.*, 2002

Nan Goldin: Conference Room 28B. From the series *Culture Inc.*, 2002

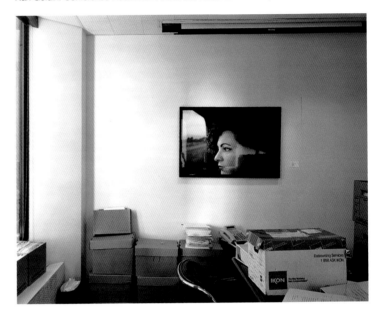

Hiroshi Sugimoto: Conference Room F. From the series *Culture Inc.*, 2002

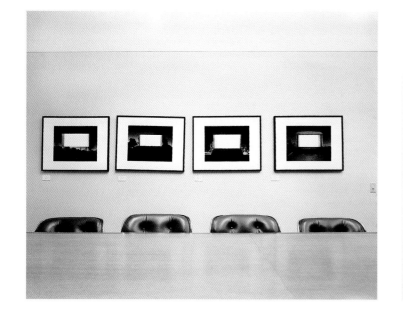

Tseng Kwong Chi: 29th Floor Secretary Cluster. From the series *Culture Inc.*, 2002

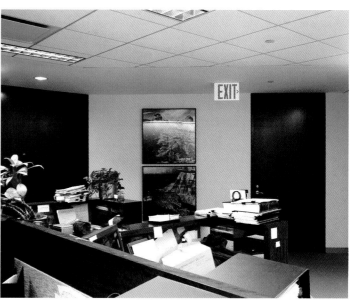

PABLO ZULETA ZAHR

Chile, b. 1978
Kunstakademie Düsseldorf, Germany, 1999 /
since 2002
Universidad Católica de Valparaíso, Chile,
1996–1999

For several years, Pablo Zuleta Zahr's work has followed a procedure that he developed in 2001. He sets up his camera, a video one that works automatically for ten hours at a time, in neutral urban spaces, selected because they are major thoroughfares. Beginning at 10am and working throughout the day, the camera indiscriminately records everyone who passes in front of the lens. Using this photographic archive, which may include up to 8,000 individual portraits, the photographer then organizes the images on his computer according to different criteria: firstly, the shots are divided by gender (male/female), secondly by the type of clothing worn, and finally by colour or pattern. It is only then that he puts his pictures together, placing groups of people with identical characteristics in the same image. Photographed in the same place and on the same day, these are nonetheless people whose paths never actually crossed. Having lost all their individuality as they passed through the image, they are now brought together by nothing more than their visual similarities. In this way, Zuleta Zahr explores the issues of globalization and mass culture that affect our society.

From the series *Baquedano, Santiago de Chile*, 2004 (detail)

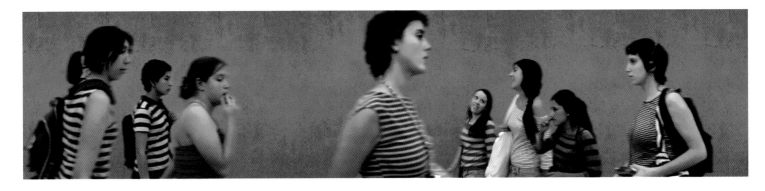

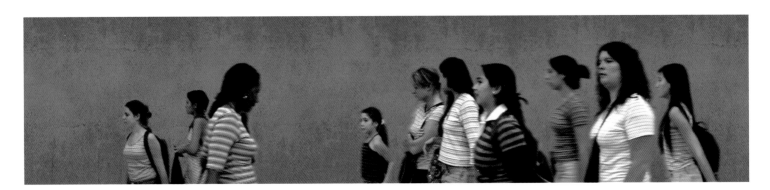

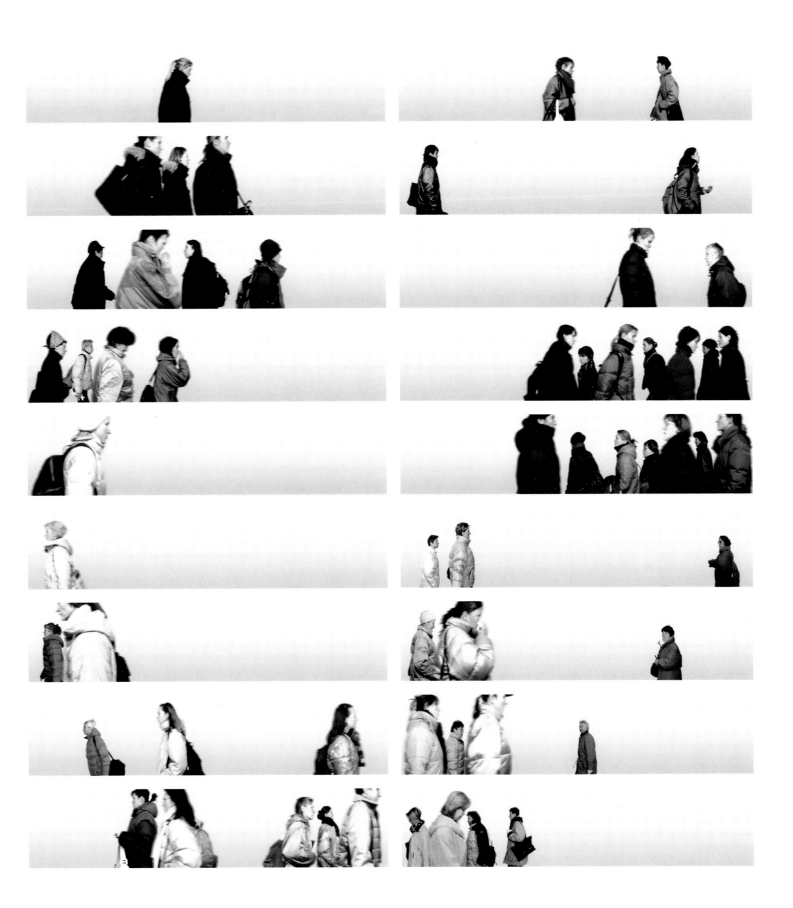

Chilean Men in Red, 2004

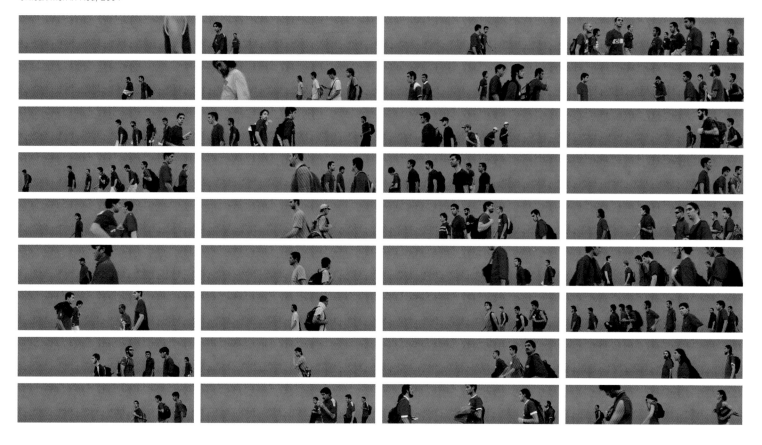

LIST OF CANDIDATES

The following candidates were invited to participate in *reGeneration*.

Mohamed Abdel Salam, Italy
Anoush Abrar, Switzerland
Jacqueline Aeberhard, Switzerland
Boaz Aharonovitch, Israel
Kathrine Ahlt, Germany
Aysha Ahmed, Australia
Marina Albu, Romania
Benedetta Alfieri, Italy
Vlado Alonso, France
Dorthe Alstrup, United States
Tasuku Amada, Japan
Miklos Ambrus, Hungary
Lykke Andersen, Denmark
Lisa Anne, Australia
Linda Antalová, Czech Republic
Tetsuomi Anzai, Canada
Daria Askari, United States
Keren Assaf, Israel
Jessica Auer, Canada
Andrej Balco, Czech Republic
Emilie Ballif, France
Sophie Ballmer, Switzerland
Christoph Bangert, Germany
Anda Bankovska, Latvia
Michelle Barker, Australia
Thibaut Baron, France
Angelika Barz, Germany
Samantha Bass, United States
Dorothée Baumann, Switzerland
Emmanuelle Bayart, France
Becky Beasley, United Kingdom
Anthea Behmn, Australia
Adam B. Bell, United States
Robert Bellamy, Norway / United Kingdom
Jaret Belliveau, Canada
Sami Benhadj, Switzerland
Aurélien Bergot, Switzerland
Manuela Bersotti, Italy
Martin Bilinovac, Austria
Leonora Bisagno, Switzerland
Nathalie Bissig, Switzerland
Andris Bizhan, Latvia
Tom Blanchard, Canada
Michael Blaser, Switzerland
Benjamin Ross Blick-Hodge, Australia
Ana Alexandra Blidaru, Romania
Rachel Bloch and Benoît Pointet, Switzerland

Yoon Bo Sim, South Korea
Jürgen Böheimer, Austria
Marco Bohr, Germany / Canada
Anne-Lise Botha, South Africa
Marilize Cecile Botha, South Africa
Kim Bouvy, Netherlands
Katarína Bricová, Czech Republic
Mauren Brodbeck, Switzerland
Corin Ashleigh Brown, South Africa
Matthias Bruggmann, Switzerland / France
Bianca Brunner, Switzerland
Diana Buda, United States
Jesse Burke, United States
Kristin Burns, United States
Jamie Cambell, Canada
Jennifer Campbell, Canada
Britta Campion, Australia
Liu Can Guo, China
José Luis Cánovas García, Spain
Roberta Carvalho, Brazil
Lisa Castagner, Northern Ireland
Alexandra Catiere, Russia
Sonia Chanel, France
Amy Tien Chang, Spain
Ben Chang, China
Song Chao, China
Yan Cheng, China
Alla Chernova, Russia
Liu Chongya, China
Dicu Ciprian-Corneliu, Romania
Ismar Cirkinagic, Bosnia
Chiara Cochi, Italy
Valéria Coelho, Brazil
Anna Collette, United States
James Collins, United States
Becky Comber, Canada
Scott Conarroe, Canada
Brenna Conley-Fonda, United States
Matthew Connors, United States
Audrey Corregan, Switzerland
Geoffrey Cottenceau, France
Daniel Gustav Cramer, Germany
Marina Cubillos Diez, Chile / Spain
Robyn Cumming, Canada
Natalie Czech, Germany
Aurore Dal Mas, Belgium
Raphaël Dallaporta, France
Wang Dan, China
Huan Danqing, China
Elena De la Rúa Rodríguez, Spain
Yolanda del Amo, Spain

Giovanni Del Brenna, Italy
Assunta Del Buono, United Kingdom
Ignacio Delgado Ros, Spain
Felix M. Diaz, United States
Nina Dick, Austria
Ana-Maria Dinescu, Romania
Justin Andrew Dingwall, South Africa
Katyuska Doleatto, Canada
Craig Doty, United States
Magali Dougados, Switzerland
John A Douglas, Australia
Marguerite Drescher, Canada
Ella Dreyfus, Australia
Anna Druzcz, United States
Kateřina Držková, Czech Republic
Bianca Dugaro, Switzerland
Joe Duggan, United Kingdom
Anna Dworak, Austria
Jan Dyntera, Czech Republic
Philipp Ebeling, Germany
Julie Edel Hardenberg, Greenland
Dan Ehrenworth, Canada
Kristaps Epners, Latvia
AnnieLaurie Erickson, United States
Yehia Eweis, Finland
Mark Excell, United Kingdom
Leo Fabrizio, Switzerland / Italy
Milan Fano Blatný, Czech Republic
Brad Farwell, United States
Carolina Feix, Germany
Adel Ferreira, South Africa
William Finger, United States
Julian Finney, United Kingdom
Dominique Fleury, France / Switzerland
Johanna Folkmann, Poland
Erwan Frotin, Switzerland / France
Miklos Gaál, Finland
David Gagnebin-de Bons, Switzerland
Gérald Garbez, France
Agnès Geoffray, France
Martie Giefert, Canada
Ashley Gilbertson, Australia
Shaun Gladwell, Australia
Davette J. Glover, United States
Alexandra Govyadkina, Russia
Birgit Graschopf, Austria
Stefanie Grätz, Germany
Jelena Griscenko, Latvia
Yann Gross, Switzerland
Lise Guyaz, Switzerland
Satu Haavisto, Finland

Mira Hartmann, Switzerland
Tarik Hayward, Switzerland
Raphael Hefti, Switzerland
Lionel Henriod, Switzerland
Rebecca Hinden, United States
Richard Hines, Canada
Annie Hogan, United States
Louise Holmgren Geertsen, Denmark
Pavla Honcová, Czech Republic
Ye Hong, China
Rob Hornstra, Netherlands
Matei Horvath-Bugnariu, Romania
Anne-Renée Hotte, Canada
Aimée Hoving, Netherlands
Pieter Hugo, South Africa
Knut L. S. G. Hybinette, United States
In Sook Kim, South Korea
Sandra Isacsson, United States
Asako Ishikawa, United States
Vanessa Jack, New Zealand
Milan Jaros, Czech Republic
Ieva Jerohina, Latvia
Sarah Johnson, United States
Mark Jones, Australia
Jeanne Ju, Canada
Caroline Juillard, Switzerland
Zhuo Kailuo, China
Fumihiko Kamemura, Japan
Anna Kanai, Switzerland / Japan
Sandra Kantanen, Finland
Adeline Keil, France
Milo Keller, Switzerland
Julia Kernbach, Germany
Idris Khan, United Kingdom
Meghan Kirkwood, United States
Charles Klein, Australia
Ray Klimek, United States
Thomas Kneubühler, Switzerland
Shay Kocieru, Israel
Petra Elena Köhle and Nicolas Vermot Petit-Outhenin, Switzerland
Ann Koozmina, Russia
Andrzej Kramarz, Poland
Barbora Krejcova, Czech Republic
Shai Kremer, United States
Karin Krijgsman, Netherlands
Gábor Arion Kudász, Hungary
Nahoko Kudo, Japan
Suk Kuhn Oh, United Kingdom
Hanneke Kuijpers, Netherlands
Barbora Kuklikova, Czech Republic

Jessica Labatte, United States
Ingvild Langgard, Norway
Elisa Larvego, Switzerland
Liga Laurenovica, Latvia
Milja Laurila, Finland
Eva Lauterlein, Germany / Switzerland
Victoria Lawson, Australia
Gi Dong Lee, United States
Ville Lenkkeri, Finland
Anni Emilia Leppälä, Finland
Yaron Leshem, Israel
Larry Letters, United States
Lucy Levene, United Kingdom
Rémy Lidereau, France
Elina Lihaceva, Latvia
Shuo Liu, China
Noomi Ljungdell, Finland
Devon Lowry, Canada
Oana Ana Lucacean, Romania
Niko Luoma, Finland
Colin D. Lyons, United States
Zoe Macdonell, Australia
Alan Maglio, Italy
Tomoaki Makino, Japan
Regina Mamou, United States
Rianka Marais, South Africa
Marcello Mariana, Italy
Vanessa Marschall, Switzerland
Michelle Mercurio, United States
Dorothée Meyer, Germany
Céline Michel, France / Switzerland
Murielle Michetti, Switzerland
Flemming Jarle Mikkelsen, Denmark
Tim Mitchell, United Kingdom
Dana Mizrahi, Israel
Fagner Monteiro Silva, Brazil
Jennifer Moon, United States
Lars Morell, Norway
Runa Maya Mork Huber, Denmark
Jen Morris, United States
Simone Moura, Brazil
Laurent Moure, France
Mr and Mrs, Australia
Zanele Muholi, South Africa
Sharon Murray, Canada
Heather Musto, United States
Dorthe Muxoll, Denmark
Mihai Alexandru Nadolu, Romania
Alpar Nagy, Romania
Ayako Nakamura, Japan
Elena Neica, Romania

Ioana Nemes, Romania
Thomas Neumann, Germany
Justyna Niedzinska, Poland
Ruchama Noorda, Netherlands
Oren Noy, Israel
Ryo Ohwada, Japan
Benjamin P. Olding, United States
Bradley N. Olson, Canada
Hiroshi Ono, Japan
John Opera, United States
Leigh Opraz, Israel
Marina Ostovic, Croatia
Danaé Panchaud, Switzerland
Pascalia Papadimitriou, Belgium
Rachel Papo, United States
Hyun-Doo Park, South Korea
Suellen Parker, United States
Ted Partin, United States
Lauris Paulus, Switzerland
Veronika Peddinghaus, Germany
Josée Pedneault, Canada
Dita Pepe, Czech Republic
Jorge Perez, Switzerland
Mathieu Perroud, Switzerland
Joao Pina, Portugal
Phillip Pisciotta, United States
Charlotte Player, United Kingdom
Katy Plummer, Australia
Jordi Pol Bercik, Spain
Fabien Pont, Switzerland
Raluca Popa, Romania
Thomás Pospech, Czech Republic
Kate Priestley, United Kingdom
Nicholas Prior, United States
Wang Qian, China
Joseph Rafferty, United States
Stephan Rappo, Switzerland
Paulina Rasinka, Poland
Elise Rasmussen, Canada
Virginie Rebetez, Switzerland
Christine Reinsch, United States
Susana Reisman, United States
Rosemaria Rex, Denmark
Léonore Robert Meer, Switzerland
Christine Robinson, United States
Nelly Rodriguez, Switzerland
Alicia Ross, United States
Flurina Rothenberger, Switzerland
Valérie Rouyer, France
Jenny Rova, Sweden
Ariel Rubin, Canada

Samuel Rubio, Switzerland
Guadalupe Ruiz Cifuentes Rihs, Colombia /
 Switzerland
Marla Rutherford, United States
Johann Ryno de Wet, South Africa
Holger Salach, Germany
Carlos and Jason Sanchez, Canada
Georgina Sanchez, United States
Leah Sandals, Canada
Julia Santamaría Pablos, Spain
Sara Sapetti, Spain
Kanako Sasaki, Japan
Stéphanie Saucez, Belgium
Martina Sauter, Germany
Sandra Scheffknecht, Austria
Paul Schneggenburger, Germany
Ursle Schneider, Switzerland
Josef Schulz, Poland / Germany
Mona Schweizer, Switzerland
Keren Shavit, Israel
Caroline Shepard, United States
Shoufay, Australia
Jari Silomäki, Finland
Olga Simón Trigo, Spain
Monika Skiers, Poland
Astrid Skumsrud Johansen, Norway
Noah David Smith, United States
Svetlana Vadimovna Smoljar, Russia
Johan Spanner, Denmark
Natasha Spirova, Russia
Vajra Spook, United Kingdom
Juergen Staack, Germany
Maria Stan, Romania
Leticia Stella-Serra, United States
Eva Stenram, Sweden
Bertrand Stofleth, France
Niels Stomps, Netherlands
Michael Strasser, Austria
Angela Strassheim, United States
Mackenzie Stroh, Canada
Cintia Stucker, Switzerland
Cathrine Sundqvist, Sweden
Stéphanie Suter, Switzerland
Shin Suzuki, Japan
Orion Szydel, Israel / Canada
Marie Taillefer, France
Shigeru Takato, Japan
Ovidiu-Florin Tarta, Romania
Jitka Teubalova, Czech Republic
Pétur Thomsen, Iceland
Heiko Tiemann, Germany

Sophie Tiller, Austria
Vladimir Tomic, Bosnia
Matús Tóth, Czech Republic
Cory Treadway, United States
Natalia Trofimenko, Australia
Chrysavgi Tsovili, Greece
Gilles Turin and Vincent Turin, Switzerland
Mieke Van de Voort, Netherlands
Awoiska van der Molen, Netherlands
Judith van Ijken, Netherlands
Nadia van Tonder, South Africa
Regina Vasileva, Uzbekistan
Henk Venter, South Africa
Tanja Verlak, Czech Republic
Alan Vieira Soares, Brazil
Gabi Vogt, Switzerland
Waded Waded, Australia
Raffael Waldner, Switzerland
Kim Waldron, Canada
Garett Walker, Canada
Chih-Chien Wang, Taiwan
Simon Ward, United Kingdom
Herbert Weber, Switzerland
Zhang Wei, China
Deborah Clare Veronica West, Australia
Anthony Whealan, Australia
Amanda Williams, Australia
Carlin Wing, United States
David Wohlschlag, Switzerland
Katherine Wolkoff, United States
Cassandra Worley, United States
Aleksandra Wronska, Poland
Song Xiaoling, China
Shangguan Xing, China
Mihail Yakovlev, Russia
Jamil Yamani, Australia
Seungwoo Yang, South Korea
Amon Yariv, Israel
Kineret Yeshurun, Israel
Fu Yuzhu, China
Maria Zervou, Netherlands
O Zhang, United Kingdom
Xue Zhijun, China
Sara Zitner, Australia
Itay Ziv, Israel
Aingeru Zorita Cadarso, Spain
Pablo Zuleta Zahr, Chile

The following schools were invited to participate in *reGeneration*.

Academy of Arts Utrecht, Utrecht, Netherlands
Akademia Sztuk Pieknych, Warsaw, Poland
Argentum, Saint Petersburg, Russia
Art Academy of Latvia, Riga, Latvia
Art Center College of Design, Pasadena CA, United States
Beijing Film Academy, Beijing, China
Bezalel Academy of Art and Design, Jerusalem, Israel
Brooks Institute of Photography, Santa Barbara CA, United States
CALARTS, California Institute of the Arts, Valencia CA, United States
C.F.P. Centro Riccardo Bauer, Milan, Italy
China Academy of Fine Arts Hangzhou, Hangzhou, China
Concordia University, Montreal, Canada
ECAL, école cantonale d'art de Lausanne, Lausanne, Switzerland
Ecole d'arts appliqués Vevey, Vevey, Switzerland
Ecole Nationale Supérieure de la Photographie, Arles, France
EFTI, Madrid, Spain
Elam School of Fine Arts, Auckland, New Zealand
Fabrica, Catena di Villorba, Treviso, Italy
FAMU, Prague, Czech Republic
Fondazione Studio Marangoni, Florence, Italy
Fotohögskolan Göteborgs Universitet, Göteborg, Sweden
Gerrit Rietveld Academie, Amsterdam, Netherlands
Goldsmiths College, London, England
GrisArt, Barcelona, Spain
Harvard University, Cambridge MA, United States
HISK, Hoger Instituut voor Schone Kunsten, Antwerp, Belgium
Hochschule für Gestaltung und Kunst Zürich, Zurich, Switzerland
Hungarian University of Crafts & Design, Budapest, Hungary
Institut tvurcí fotografie FPF Slezské univerzity, Opava, Czech Republic
International Center of Photography, New York NY, United States
Kent Institute of Art and Design, Rochester, England
Kunstakademie Düsseldorf, Düsseldorf, Germany

La Cambre, Brussels, Belgium
La Esmeralda, Mexico City, Mexico
Les Gobelins, Paris, France
London College of Communication, London, England
Luxun Academy of Fine Arts, Shenyang, China
National Academy of Fine Arts, Oslo, Norway
Nihon University, Tokyo, Japan
Nottingham Trent University, Nottingham, England
Nova Scotia College of Art and Design, Halifax, Canada
Post-St. Joost Photography, Breda, Netherlands
Prilidiano Pueyrredón, Buenos Aires, Argentina
Rhode Island School of Design, Providence RI, United States
Rijksakademie van Beeldende Kunsten Amsterdam, Amsterdam, Netherlands
Rochester Institute of Technology, Rochester NY, United States
Royal College of Art, London, England
Royal Danish Academy of Fine Art, Copenhagen, Denmark
Ryerson University, Toronto, Canada
San Francisco Art Institute, San Francisco CA, United States
Sankt-Peterburgskii Gosudarstvennyi Universitet, Saint Petersburg, Russia
School of the Art Institute of Chicago, Chicago IL, United States
School of Visual Arts, New York NY, United States
Shingu College, Kungi-Do, Korea
Tokyo Polytechnic University, Tokyo, Japan
Tshwane University of Technology, Pretoria, South Africa
UNESP, São Paulo State University, São Paulo, Brazil
Universidade da Amazônia Unama, São Paulo, Brazil
Universität für angewandte Kunst, Vienna, Austria
Universitatea de Arte si Design Cluj, Cluj, Romania
Universitatea nationala de arte Bucuresti, Bucarest, Romania
University of Art, Tehran, Iran
University of Art and Design Helsinki, Helsinki, Finland
University of New South Wales, Paddington, Australia
Yale University School of Art, New Haven CT, United States

2–3 © Josef Schulz / VG Bild-Kunst 6 © Shigeru Takato 9 © Eva Lauterlein 10 © Song Chao 15 © Gábor Arion Kudász 18, 19, 20, 21 © 2005 Anoush Abrar 22, 23, 24, 25 © Keren Assaf 26, 27, 28, 29 © Christoph Bangert 30, 31, 32, 33 © Samantha Bass 34, 35, 36, 37 © Jaret Belliveau 38, 39, 40, 41 © Marco Bohr 42, 43, 44, 45 © Mauren Brodbeck 46, 47, 48, 49 © Matthias Bruggmann 50, 51, 52, 53 © Bianca Brunner 54, 55, 56, 57 © Song Chao 58, 59, 60, 61 © Natalie Czech / VG Bild-Kunst 62, 63, 64, 65 © 2004 Raphaël Dallaporta 66, 67, 68, 69 © Kateřina Držková 70, 71, 72, 73 © Julie Edel Hardenberg / Greenland Home Rule Government / Air Greenland Inc. 74, 75, 76, 77 © Leo Fabrizio 78, 79, 80, 81 © Miklos Gaál 82, 83, 84, 85 © Gérald Garbez 86, 87, 88, 89 © Tarik Hayward 90, 91, 92, 93 © 2002 Raphael Hefti / ECAL 94, 95 © Aimée Hoving, Anoush Abrar 96, 97 © Aimée Hoving 98, 99, 100, 101 © Pieter Hugo. Courtesy of Michael Stevenson Gallery, Cape Town 102, 103, 104, 105 © Milo Keller / ECAL 106, 107, 108, 109 © Idris Khan. Courtesy of Victoria Miro Gallery, London 110, 111, 112, 113 © Gábor Arion Kudász 114, 115, 116, 117 © Eva Lauterlein 118, 119, 120, 121 © Lucy Levene 122, 123, 124, 125 © Rémy Lidereau 126, 127, 128, 129 © Marcello Mariana 130, 131, 132, 133 © Oren Noy 134, 135, 136, 137 © Ryo Ohwada 138, 139, 140, 141 © Suellen Parker 142, 143, 144, 145 © Ted Partin 146, 147, 148, 149 © Charlotte Player 150, 151, 152 © Nicholas Prior. Courtesy of Yossi Milo Gallery, New York 153 © Nicholas Prior. Courtesy of Yossi Milo Gallery / FareStart / Getty Images 154, 155, 156, 157 © Valérie Rouyer 158, 159, 160, 161 © Marla Rutherford 162, 163, 164 165 © Johann Ryno de Wet 166, 167, 168, 169 © Martina Sauter 170, 171, 172, 173 © Josef Schulz / VG Bild-Kunst. Courtesy of Galerie Heinz-Martin Weigand, Ettlingen 174, 175, 176, 177 © Mona Schweizer 178, 179, 180, 181 © Caroline Shepard 182, 183, 184, 185 © Angela Strassheim. Courtesy of Marvelli Gallery, New York 186, 187, 188, 189 © Cathrine Sundqvist 190, 191, 192, 193 © Shigeru Takato 194, 195, 196, 197 © 2005 Pétur Thomsen 198, 199, 200, 201 © Mieke Van de Voort 202, 203, 204, 205 © Raffael Waldner 206, 207, 208, 209 © Chih-Chien Wang 210, 211, 212, 213 © Carlin Wing 214, 215, 216, 217 © Pablo Zuleta Zahr

ACKNOWLEDGMENTS

reGeneration has been a vast project, requiring the collaboration of numerous individuals and institutions. The authors wish to express their gratitude to all of those who have contributed to its realization.

Firstly, we wish to thank the directors and teachers of the schools that were invited to submit candidates: Hans Aarsman, Rijksakademie van Beeldende Kunsten; Emily Andersen and Cary Welling, Nottingham Trent University; Yaarah Bar-On and Yossi Berger, Bezalel Academy of Art and Design; Jaroslav Barta and Victor Kolar, FAMU; Richard Benson, Minoru Okazaki and Tod Papageorge, Yale University School of Art; Phil Bergerson, Robyn Cumming and Wayne Pittendreigh, Ryerson University; Michel Berney and Christian Rossier, Ecole d'arts appliqués Vevey; Vladimír Birgus, Institut tvurcí fotografie FPF Slezské university; Nayland Blake, Robert Blake and Phillip S. Block, International Center of Photography; Kaucyila Brooke, CALARTS; Victor Burgin, Goldsmiths College; Arnaud Claass and Patrick Talbot, Ecole Nationale Supérieure de la Photographie; Alvin Comiter, Jan Peacock and Gary Wilson, Nova Scotia College of Art and Design; Linda Connor and Jack Fulton, San Francisco Art Institute; Antonio Corral, GrisArt; Geraint Cunnick, Kevin Liggett and Caroline Scott, Kent Institute of Art and Design; Barbara DeGenevieve, School of the Art Institute of Chicago; Flip Du Toit, Tshwane University of Technology; Just Evergon and Josée Pedneault, Concordia University; Pierre Fantys and Pierre Keller, ECAL; Ulrich Görlich, Hochschule für Gestaltung und Kunst Zürich; Andrejs Grants, Art Academy of Latvia; Jacqueline Hassink, Harvard University; Ioan Horvat-Bugnariu, Universitatea de Arte si Design Cluj; Jos Houweling and Marjo van Baar, Gerrit Rietveld Academie; Ian Howard, University of New South Wales; Per Bak Jensen, Royal Danish Academy of Fine Art; Annika Karlsson Rixon, Fotohögskolan Göteborgs Universitet; Dennis Keeley, Art Center College of Design; Iosif Kiraly, Universitatea nationala de arte Bucuresti; Lin Jian Jiao and Liu Li Hong, Luxun Academy of Fine Arts; Orlando Maneschy, Universidade da Amazônia; Beatriz Martínez Barrio and Agustín Pérez de Guzmán, Efti; Domingo Mazzone, Prilidiano Pueyrredon; Gary Metz and Eva Sutton, Rhode Island School of Design; Caroline Mierop, La Cambre; Eline Mugaas, National Academy of Fine Arts; Therese Mulligan and Ken White, Rochester Institute of Technology; Kari Pyykönen and Merja Salo, University of Art and Design Helsinki; Olivier Richon, Royal College of Art; Julian Rodriguez, London College of Communication; Gabriele Rothemann, Universität für angewandte Kunst; Thomas Ruff, Kunstakademie Düsseldorf; Hans Scholten and Maartje van den Heuvel, Post-St. Joost Photography; Johan Swinnen, HISK; Charles H. Traub, School of Visual Arts; Roberta Valtorta, C.F.P. Centro Riccardo Bauer; Xu Zhi Gang, Beijing Film Academy.

We are also grateful to the many individuals working in galleries, museums and other institutions for their help and guidance: PoYin AuYeung, Roger Ballen, Anthony Bannon and Alison Nordstrom of George Eastman House, Joan Fontcuberta, Fu Yuzhu, Kathy Grundlingh of the Michael Stevenson Gallery, Pierre Huber of Art & Public, Diana Martinez, Marvelli Gallery, Yossi Milo Gallery, Victoria Miro Gallery, Grazia Neri, Virginie Otth, Tony Pritchard, Galerie Heinz-Martin Weigand, Pascale and Jean-Marc Yersin of the Musée suisse de l'appareil photographique.

We also wish to express our gratitude to our partners in Switzerland, without whom a project of this scope would never have been possible. In particular, we thank the Manufacture Jaeger-LeCoultre, its director general Jérôme Lambert, Stéphanie Barthoulot, Bénédicte Ferlet and Isabelle Gervais.

Our thanks as well to the Fondation Nestlé pour l'Art, and its director Rosmarie Richner, for much-needed help with the events organized for the participants, and to the Ecole hôtelière de Lausanne, who graciously provided assistance to the visiting photographers: Stéphane Galéazzi, Thomas Hartleyb and Christian Michelet have been most generous. Profound thanks, too, to DHL, who graciously consented to cover the transport of works for the exhibition. Our media partner, *Le Temps*, of Geneva, has also been most supportive of the project, and we owe a debt of thanks in particular to Valérie Boagno and Carine Cuérel.

We wish to thank the Canton of Vaud, especially Anne-Catherine Lyon, Councillor of State, Brigitte Waridel, Head of Cultural Activities, and Sophie Donche-Gay.

Our thanks too to the Fondation de l'Elysée, its president Jean-Claude Falciola and its members Béatrice Béguin, Jacques Pilet and Brigitte Waridel.

We are most grateful to the Aperture Foundation, New York, for the American edition of this book and for hosting the exhibition in their magnificent new galleries. Many thanks to Ellen S. Harris, Lesley A. Martin, Melissa Harris and Diana Etkins.

As always, a project of this nature requires a tremendous effort on the part of the Musée de l'Elysée staff, and we voice our gratitude to: Vincent Angehrn, Nathalie Choquard, Jean-Jean Clivaz, Corinne Coendoz, Pierre Furrer, Alessandra Gerber, Daniel Girardin, Christine Giraud, Michèle Guibert, Nathalie Hellen, Leila Klouche, Pascale Pahud, Ben Rengli, Sacha Roulet, André Rouvinez, Hans-Ulrich Spalinger and Michèle Vallotton. Special thanks to Radu Stern, Head of the Musée's Education Department, who liaised with all the schools invited to participate in the project.

We wish to thank Thames & Hudson for a heroic effort in making this book happen in record time. Our thanks to Thomas Neurath and Constance Kaine, as well as to Jamie Camplin, Johanna Neurath, Jenny Wilson, Hélène Borraz and Anne Levine.

Finally, we owe a word of thanks to Gerhard Steidl for the superb printing of the book, and to Maggi Smith, for a most elegant design.